MIDDLESBROUGH

ARAF CHOHAN

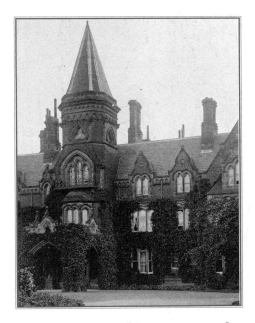

Grey Towers was one of the most prestigious of Middlesbrough's old mansions. Built between 1867 and 1875, it remained in family use until 1931, when the house and grounds were given to the Council and used as part of Poole Hospital. Although its future is uncertain, it is hoped that Grey Towers will survive, unlike so many of Middlesbrough's buildings that have been lost forever.

The History Press

Dedication

To the people of Middlesbrough; my mother, Nafees Akther Chohan; and my late father, my uncle and my loving nephew – Ghulam Sarwar Khan Chohan, Chirag Din Chohan and Haroon Bari Chohan.

It is said that people make a place, and this is never more true than in Middlesbrough where the hospitable, friendly and genuinely welcoming people are second to none. I am both privileged and lucky to have been born in Middlesbrough, my home town.

Araf Khan Chohan

First published in 1998
This edition first published in 2009

The History Press
The Mill, Brimscombe Port
Stroud, Gloucestershire, GL5 2QG
www.thehistorypress.co.uk

© Araf K. Chohan, 1998, 2001, 2002, 2005, 2009

The right of Araf K. Chohan to be identified as
the Author of this work has been asserted in accordance
with the Copyrights, Designs and Patents Act 1988.

ISBN 978 0 7524 5037 7

Typesetting and origination by The History Press
Printed in Great Britain

CONTENTS

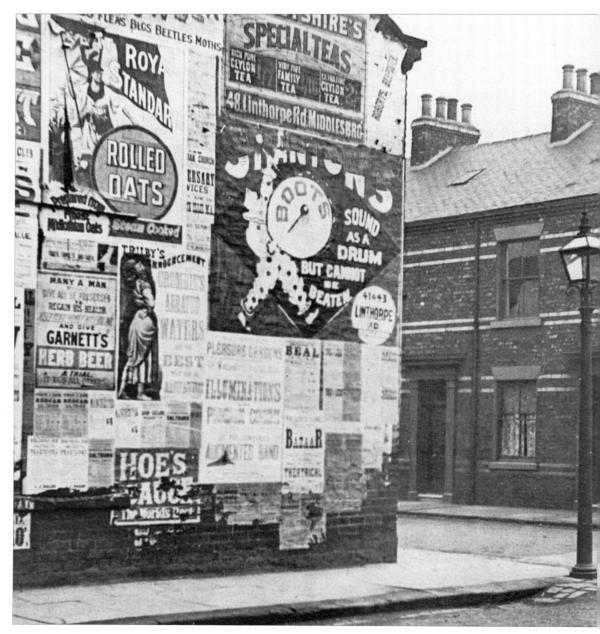

Gable ends were as popular for advertising in Victorian and Edwardian times as they are today. However, unlike today they usually filled the whole gable end (as seen here in an older part of town) and must have been quite a colourful attraction in an otherwise grey environment.

INTRODUCTION

Middlesbrough and its history have been the subject of countless books, ranging from Professor Asa Briggs's *Victorian Cities* to the many excellent works by local historian Norman Moorsom. My intention in this book is to try to stimulate nostalgia for a time long ago and not to present a chronological photographic history of the town. It is merely a personal selection from images that I have collected over the last thirty years, put together to record the immense changes which have taken place in the town in which I was born and brought up during the 1950s and 1960s. In those not too distant days, much of the old Victorian town was still intact and had yet to endure the destructive changes brought about by the planners and developers.

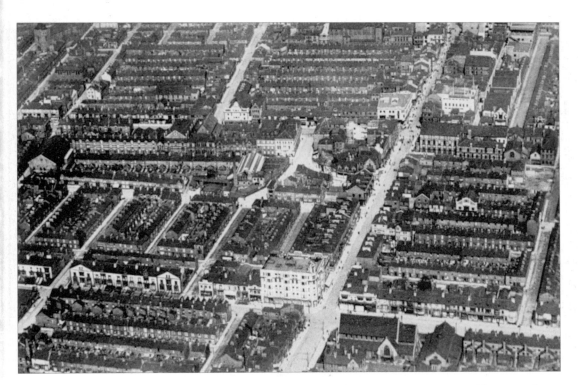

This late 1930s aerial view of the town centre clearly shows the once numerous terraced houses and streets that have been replaced by the large enclosed shopping centres of today. The large road running top to bottom is Linthorpe Road.

Since I first started collecting photographs of Middlesbrough as a teenager in 1966, I have managed to amass many images of the town which have never previously been published in book form. In the past, I have given total access to my collection to other writers and have permitted their use in other publications, such as Robin Cook's *Middlesbrough in Old Picture Postcards* which has more than 60 photographs taken from my collection. When mulling over the present book, therefore, I decided that I would try, as far as possible, to include photographs which had not previously been included in other books. Although it was quite a task to choose the final 237 pictures out of my collection of more than 1,100, I am pleased to say that about 90 per cent of those selected have never before been published in any book.

The history of modern Middlesbrough, which only began with the laying out of the 'new' town in 1830, is a history of people coming from all parts of the British Isles to an industrial boom town. As the fame of the town spread, the inflow of people continued, as it did with my own family, the first member of which, my uncle, settled here in 1925, followed by my father in 1937 and my mother in 1949. They, like so many before them, put down their roots in the town and made it their home. However, the Middlesbrough of the last years of the twentieth century is almost unrecognisable from the town of fifty and more years ago. That Middlesbrough with its iron and steel works, its docks and shipyards and its tightly packed terraces of Victorian houses is a Middlesbrough now gone, a Middlesbrough that was and a Middlesbrough of memories past. I hope therefore that, through these photographic images, the reader can, for a short time, travel back to see the Middlesbrough that existed before the changes of recent years took their toll and altered the urban townscape forever.

Finally, I hope that this publication will give as much pleasure to the reader as it did to me in its compilation, and that this glimpse of Middlesbrough of yesteryear will go a little way towards stimulating the minds and hearts of those today in preserving the best of the past for future generations.

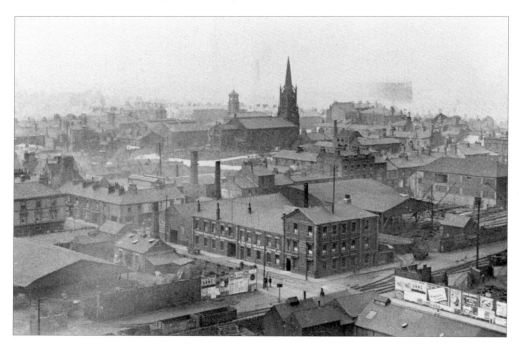

Familiar landmarks of the Old Town, such as St Hilda's Church and the Old Town Hall, are seen here in a view from the top of the Transporter Bridge, *c.* 1912.

SECTION ONE

THE OLD TOWN –
'OVER THE BORDER'

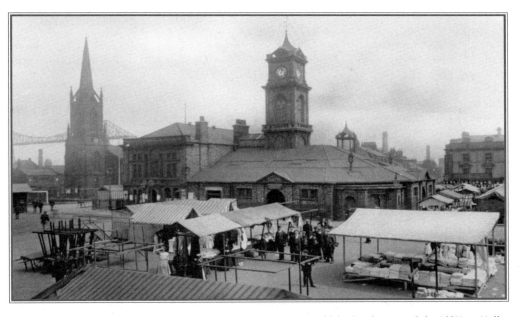

All the major landmarks of the Old Town, the Transporter Bridge, St Hilda's Church spire and the Old Town Hall, look down on the Market Square.

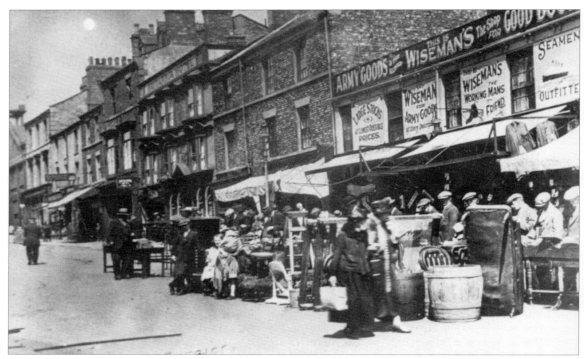

Overflowing from the market place, market stalls ran down both East Street (above) and South Street (below), selling all manner of goods. The more popular of the two, South Street Market, continued trading until 1959.

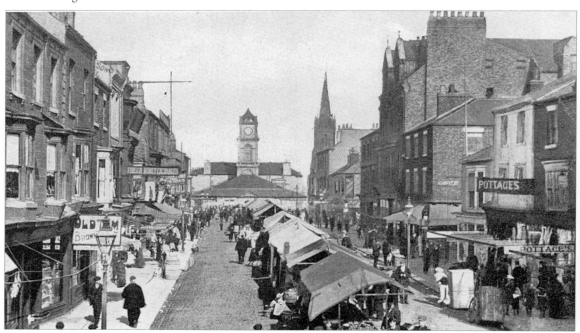

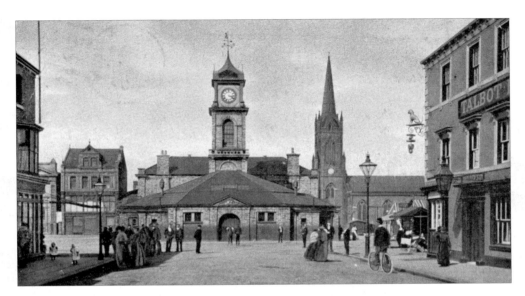

Peering into the Market Square from South Street, the scene is dominated by the centrally sited Old Town Hall of 1846 and St Hilda's Church, which was consecrated in 1840. North, South, East and West Streets radiated from Market Square which was then the hub of the old town's commercial heart. Other streets branching from the main arteries were laid out in a grid pattern.

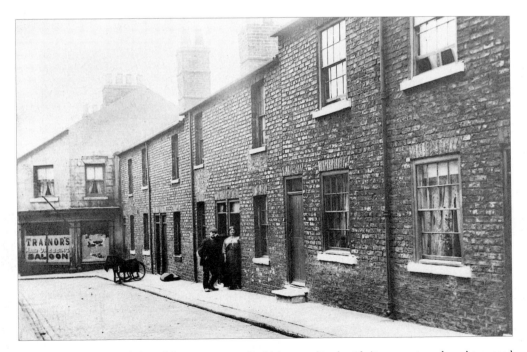

A typical side street of the Old Town, many of which were lined with 'two up, two down' terraced houses, tall, narrow and very mean-looking.

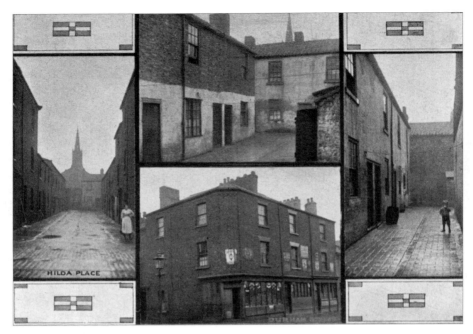

This composite photograph vividly shows the density and tightness of the Old Town. Hilda Place was off Durham Street and St Hilda's Church spire can be seen just behind the buildings in the centre top photograph.

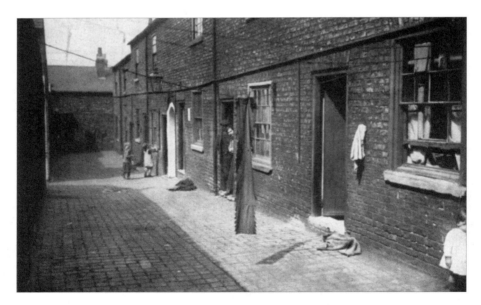

Somehow the sun manages to penetrate Mason Street, in reality more a yard, and briefly brightens otherwise depressingly drab surroundings. Tightly packed with Black Lion (later York Tavern) Yard and Moon's (later Garrick's) Yard, Mason Street lay between West Street and Dacre Street.

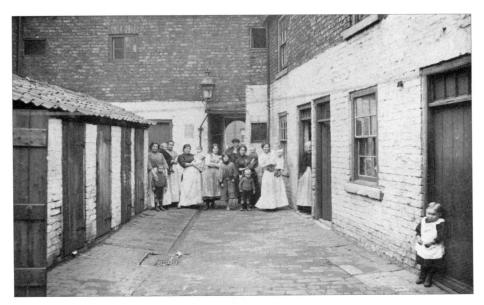

Graham's Yard, off Richmond Street. Although stark and unhealthy, an attempt has been made to brighten up the lower aspect of the buildings by whitewashing. Note the outside privies directly opposite the dwellings.

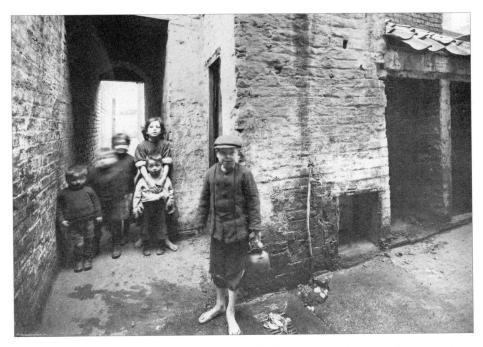

Without water or sanitation in their homes, these children, some barefooted, collect water from a communal tap in the yard. Demolished in 1935, this is Robinson's Yard, Lower East Street.

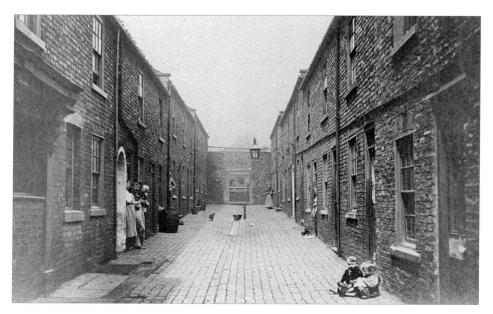

Back-to-back houses such as these in Durham Place, a cul-de-sac off Cleveland Street, abounded in the Old Town. No more than a narrow dreary alley, it did have the Golden Lion public house, dating from 1833, partially seen here on the extreme left.

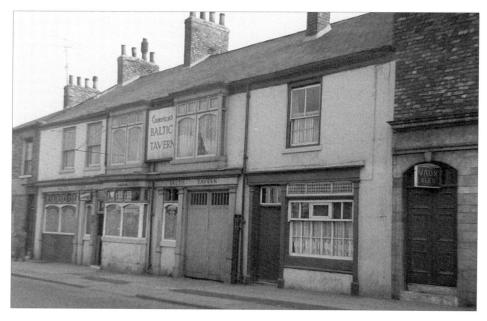

In use until about 1960, the Baltic in Commercial Street was unusual in being one of the few public houses in Middlesbrough to be known as a tavern. Among others were the Oxford, the Miner's, the Mariner's, the Lamp and the York.

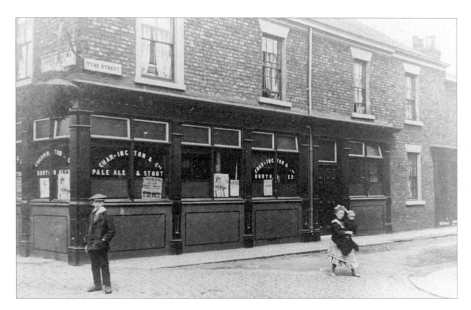

Located at the corner of Tyne and Lower Gosford Streets was the Cromwell Hotel. First licensed in 1868, it survived until the early 1960s.

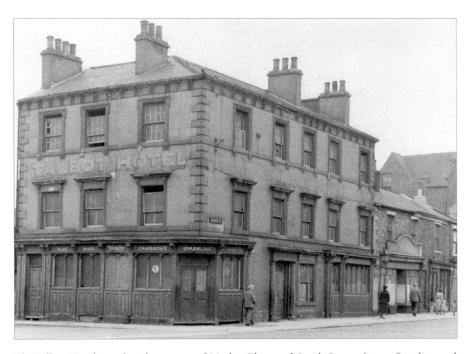

The Talbot Hotel stood at the corner of Market Place and South Street. It was first licensed in 1844 and was demolished in the late 1950s. The Talbot was nicknamed 'the Dog' and also 'Sacker's' after a former landlord, Peter Sacker, who died in 1867.

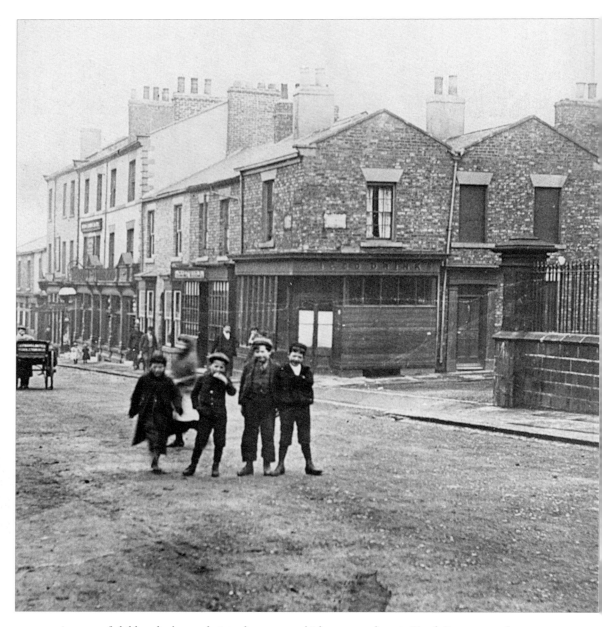

A group of children look eagerly into the camera which captures them in North Street, near the corner of Church Place. The railings on the right mark the boundary of St Hilda's churchyard, while further along the street the Middlesbrough Hotel stands on the site of the original Middlesbrough Farm House and nearby priory.

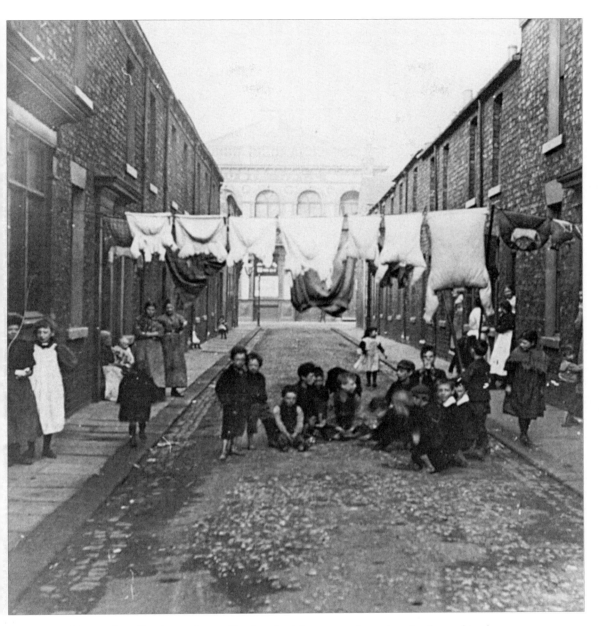

Hardships endured by the residents of back-to-back houses, as shown here by the washing hung across Mineral Street, included the marked lack of space and amenities that even a small back yard would have provided. Nearby industrial pollution and the substandard nature of the street would make all the 'possing and scrubbing' a doubly difficult chore. On a lighter note, the Oxford Palace of Varieties can be seen at the end of the street.

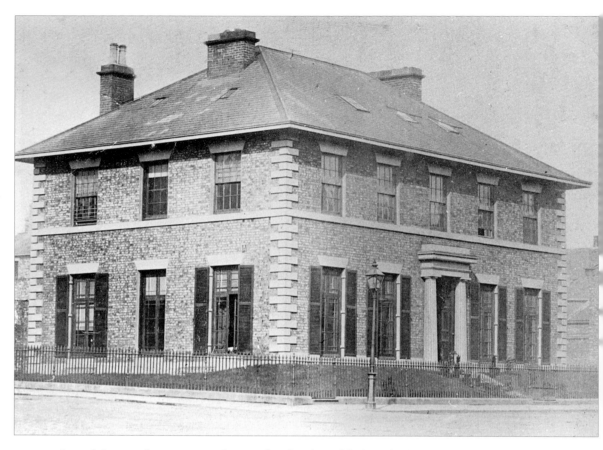

One of the very few surviving photographs of early Middlesbrough, this shows the large detached house that once stood in Cleveland Street, occupying the block between Gosford Street and Feversham Street. Dating from the 1830s, this was the home of John Gilbert Holmes whose shipyard near Ferry Road made him one of the town's earliest employers. In 1864, the National Provincial Bank (now NatWest) moved here and rebuilt the property in the Classical style. Opened on 16 December 1872, the building still stands today and was used for banking until January 1939, when the business was transferred to a new building in Albert Road.

SECTION TWO
THE RIVER & BRIDGES

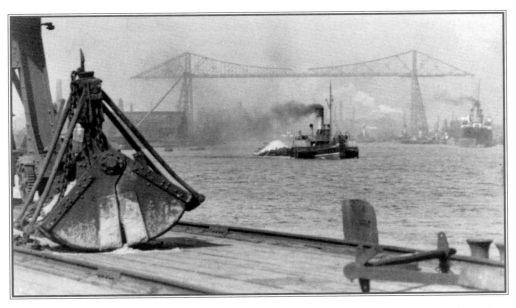

A once-typical scene near the docks. Looking up-river to the Transporter Bridge, railway lines, cranes, tugboats, ships and smoke all combine to give a very industrial view.

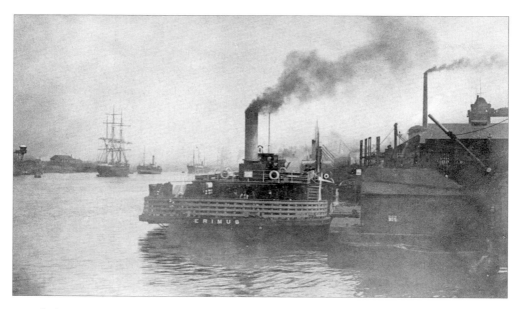

Launched on 15 September 1888 and able to carry 920 passengers, the ferry steamer *Erimus* is seen here 'in a state of readiness' for its river crossing. The *Erimus* and its sister ferry, the *Hugh Bell*, became redundant after the opening of the Transporter Bridge in 1911 and were sold, on 21 May 1912, for £725 to a Southampton firm.

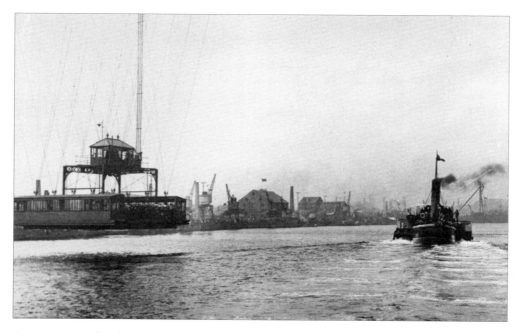

A steam-powered paddle tug gives clearance for the 'car' of the Transporter Bridge to complete its journey across the Tees.

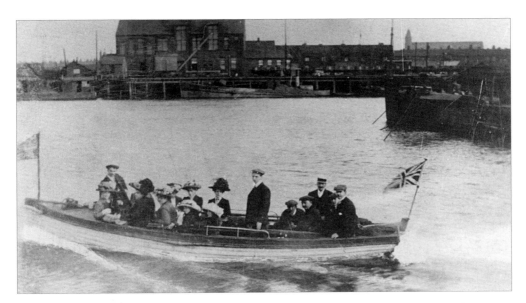

Taken at the historic Newport ferry landing, this is not the usual picture of workmen heading across the river. More likely these well-dressed passengers are marking a special occasion. The outline of St Cuthbert's Church (on the extreme right) is just visible on the Newport skyline.

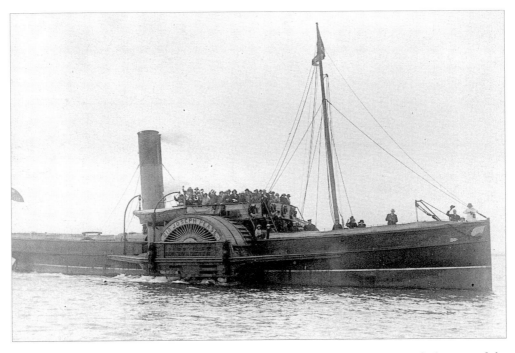

These folk too, it seems, may be on a special outing on the *Sir Joseph Pease*, named after one of the founding fathers of modern Middlesbrough.

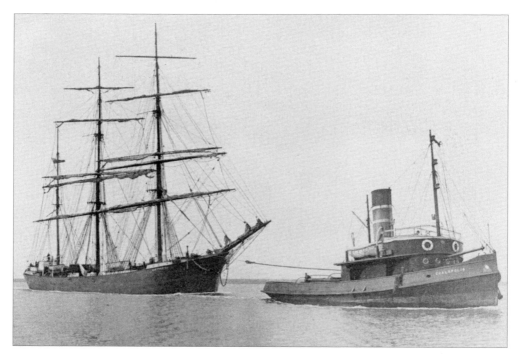

Coalopolis, a brand-new tug of the Tees Towing Company, is seen here on the Tees, towing the *Garnell* on 10 April 1923. The *Coalopolis* crossed the Atlantic in 1925 to Halifax, Nova Scotia, then on to Toronto in 1947, where, in 1971, she was broken up, after forty-eight years in service.

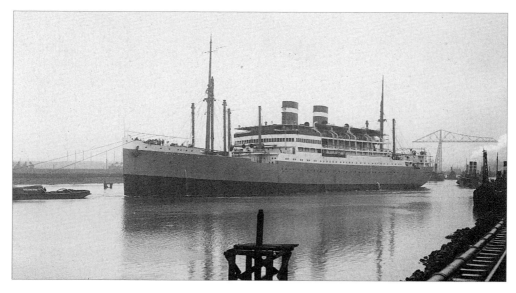

Such scenes of grace and dignity as this were once a regular occurrence on the Tees. Here, as the Transporter recedes into the distance, the *Santa Maria* makes her way, under tow, to the sea.

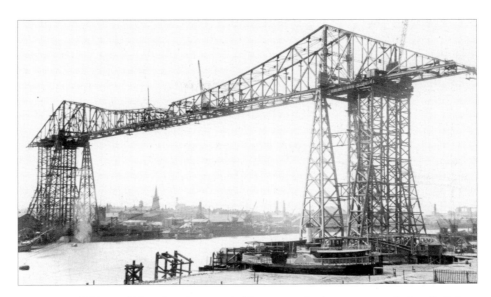

Soon the scaffolding will be taken down as the Transporter Bridge nears completion. Built by a Glasgow company at a cost of £84,000, its highest point reaches over 220 ft; the central span is 570 ft with a total length of 850 ft. Seen here from the Port Clarence side, it is Middlesbrough's most famous structure.

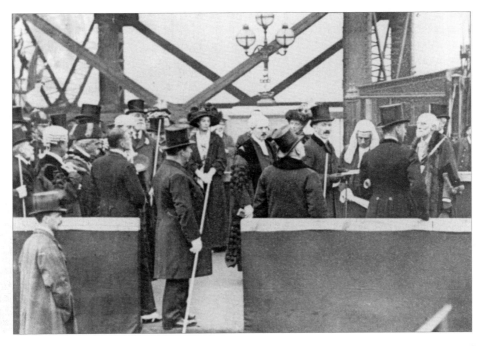

The bridge was officially opened on Tuesday 19 October 1911 by HRH Prince Arthur of Connaught, the son of the Prince Arthur who opened Albert Park forty-three years earlier.

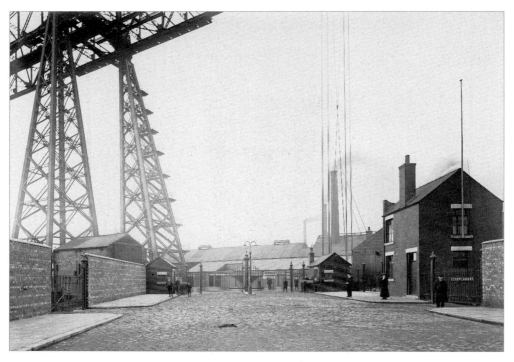

This is the Middlesbrough approach along Ferry Road, where large wrought-iron gates spanning the carriageway prevented vehicles accidentally falling into the safety net before the 'transporter car' was in.

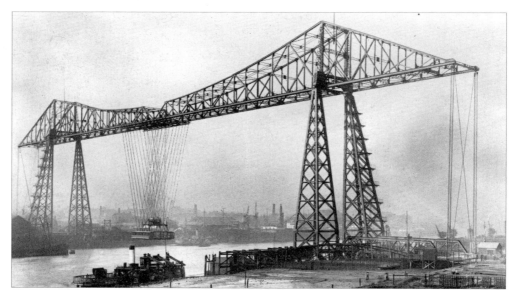

The view above shows the 'car' in mid-river, crossing from Middlesbrough to Port Clarence, a scene familiar to generations on both banks of the Tees.

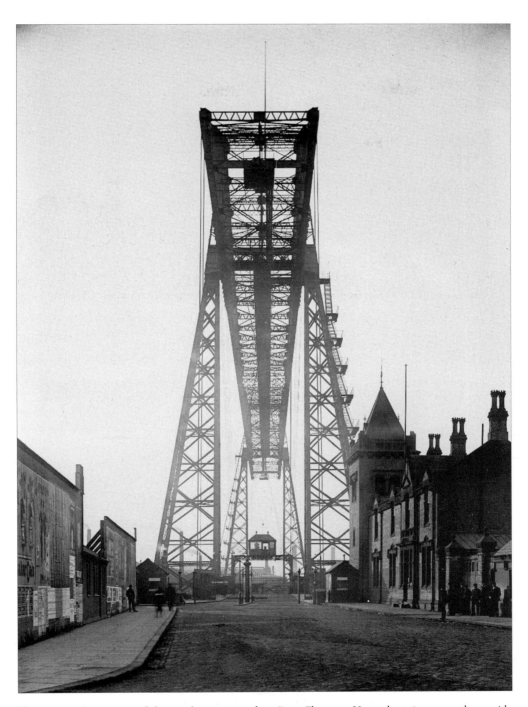

This spectacular view is of the northern approach at Port Clarence. Here, day trippers to the seaside from Middlesbrough would continue their journey to Seaton Carew, and the daily throng of workers would go on their way to the extensive industrial plants and shipyards.

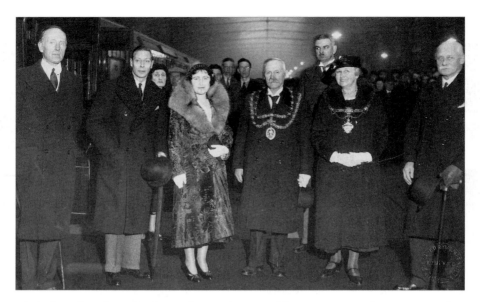

The Duke and Duchess of York, seen here at the start of their visit to open the new Tees Bridge, were welcomed initially at Darlington station by the town's mayor and mayoress, the Marquess of Londonderry and the Chief Constable of Middlesbrough, before going on to Newport.

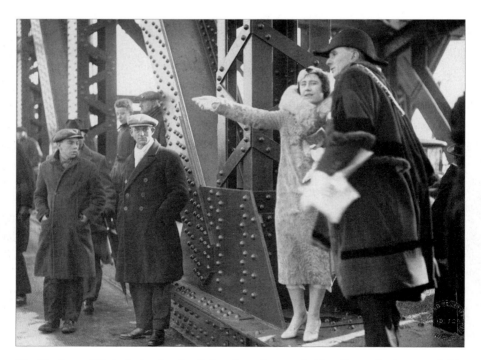

The Duchess of York during her 'walkabout' on the new bridge. Two onlookers, probably specially invited, seem quite awestruck at being in such close proximity to her highness.

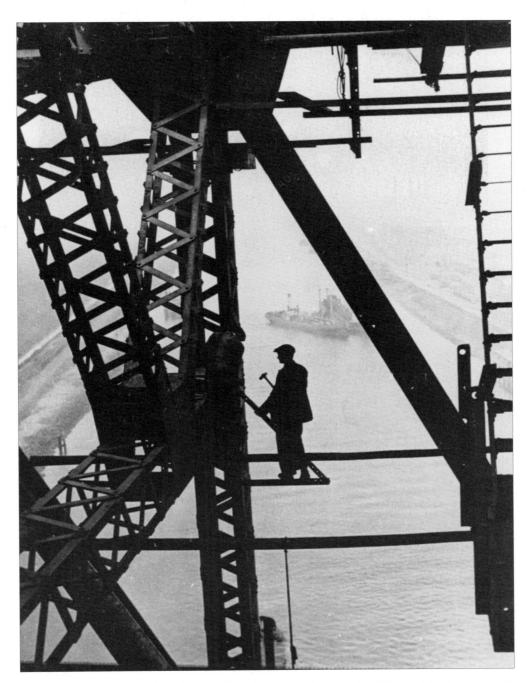

Working on a knife edge, a lone figure high in the structural steelwork of Newport Bridge represents the great tradition and expertise of Middlesbrough's engineers, once renowned throughout the world.

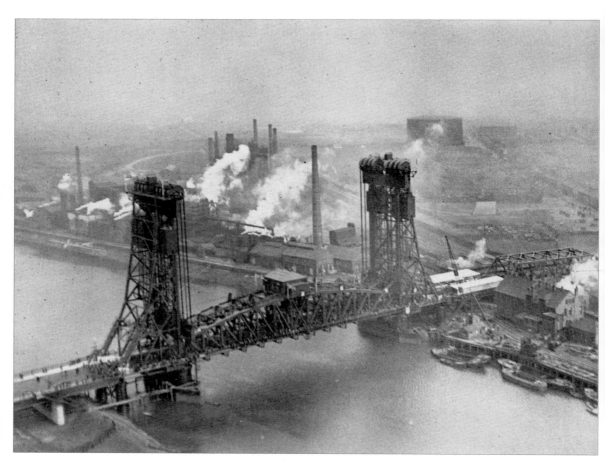

The Tees (Newport) Bridge was opened on Wednesday 28 February 1934, by their royal highnesses the Duke and Duchess of York. Seen here on its opening day, the bridge was built by the local firm of Dorman Long at a cost of £512,353, and linked the counties of Yorkshire and Durham. The view shows the industrial activity on the Yorkshire side at Newport.

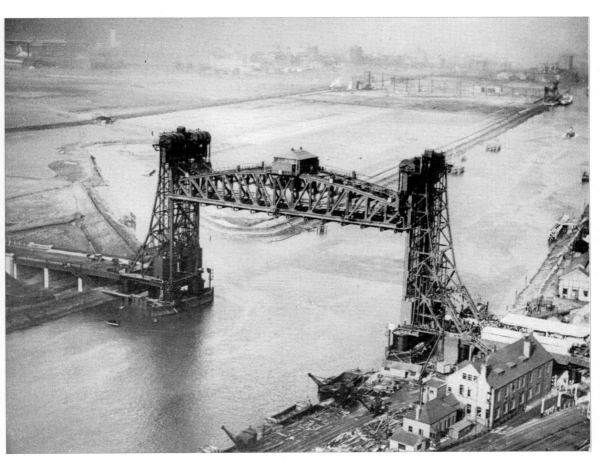

Photographed on the same day, the bridge is seen here raised to display the technical marvel of its workings to the royal couple. Sadly now fixed at road level as a cost-saving measure, the bridge was last raised on Sunday 18 November 1990.

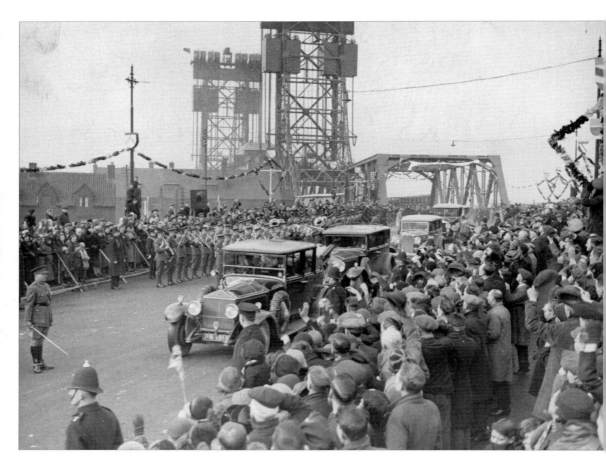

After the official opening ceremony, crowds cheer the royal party as they make their way to Middlesbrough Town Hall for lunch, before heading off to Darlington for the return train to London. On the extreme left is Newport House, part of the former Hustler Granary, dating from the 1660s, which was one of the oldest buildings in the Middlesbrough area.

SECTION THREE
DOCKS & INDUSTRIES

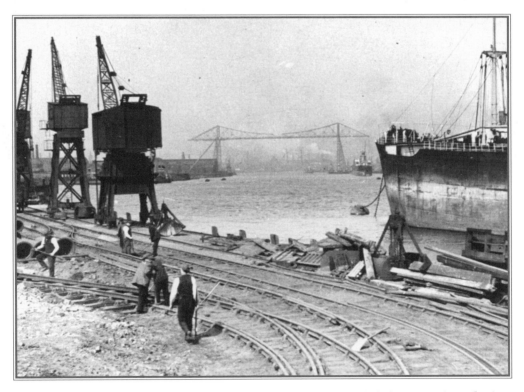

Railwaymen repairing the two different types of track near Middlesbrough docks. One track was for the movement of mobile cranes along the wharves, while the other was a conventional railway.

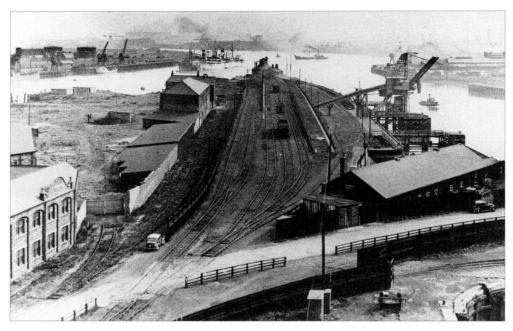

An early aerial view of Dock Point, looking downstream over the cluster of railway lines known as Dock Point sidings. The Customs Watch House and Harbour-master's Office can be seen in the distance.

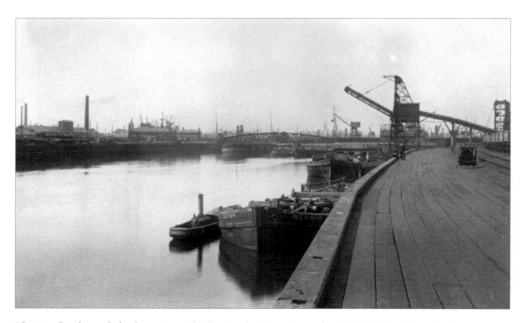

The Dock Channel, looking towards the Dock Gates from the North Wharf. This is the entrance channel to Middlesbrough docks. A coal conveyor is a prominent feature on the right, and just beyond is the former swing bridge which was dismantled in March 1996.

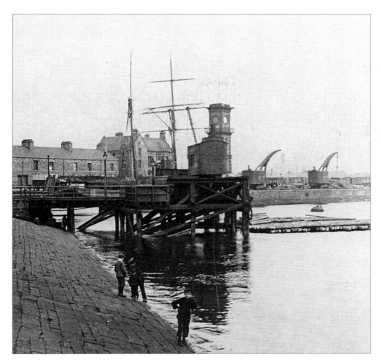

The view of a masted ship moored in front of the row of terraced houses which used to be Dock Street is now beyond the memory of even the oldest residents. The houses have gone, as have the original dock tower and cranes.

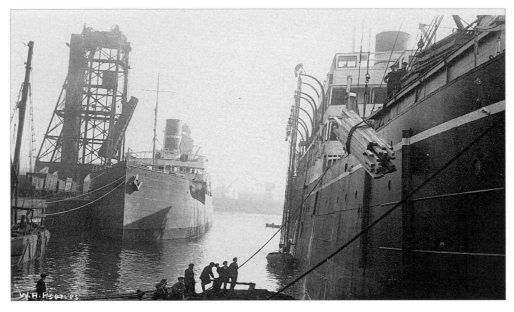

The sight of timber being loaded on to a large ocean-going vessel is a reminder of the extensive timber yards and sawmills which once lined the banks of the Tees, particularly those of the owners of the Middlesbrough Estate whose wharf was adjacent to the present Riverside Stadium of Middlesbrough Football Club.

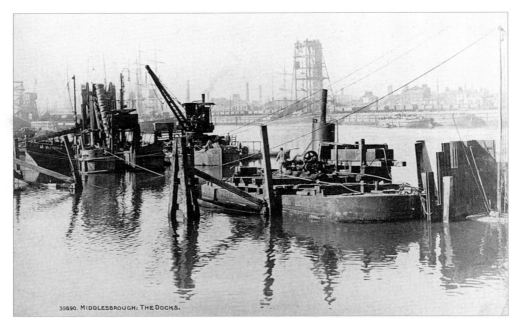

39890. MIDDLESBROUGH: THE DOCKS.

A tranquil river scene, probably from around 1910. In the background, one of the tower legs of the Transporter Bridge, which was then under construction, is starting to rise above the river, while, to the left, tall-masted ships can still be seen on the river.

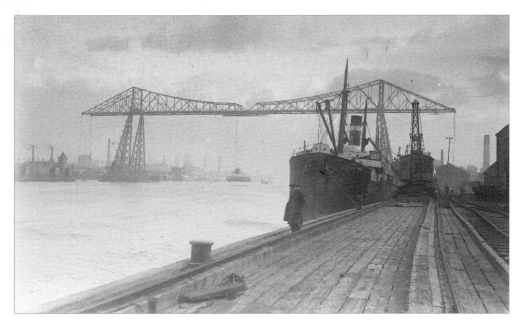

Once a familiar sight, a large ship is berthed in the shadow of the Transporter Bridge on the Middlesbrough side of the Tees.

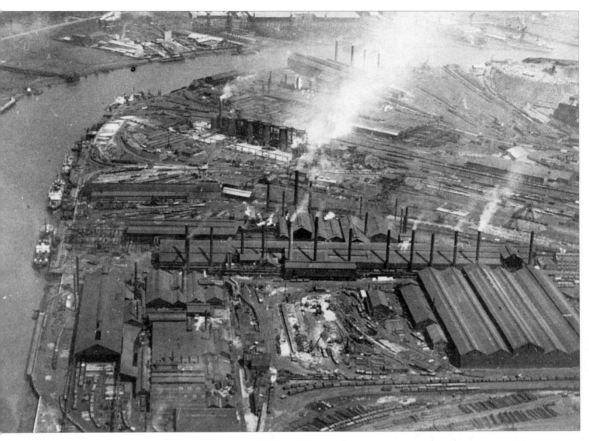

The price which Middlesbrough had to pay for the worldwide reputation of its highly successful industries was the smoke and grime emanating from the foundries and mills of the Ironmasters District. It was here that many of the giants of the iron and steel industry had their birth and flourished for a century before the creation of the nationalised British Steel. Belonging to an exhaustive list, some of the names that can still be remembered are Dorman Long, Britannia, Bolckow-Vaughan, Linthorpe, Richard Hills, Fox-Head's, Shaw's Foundry, Samuelson's and Gjers Mills.

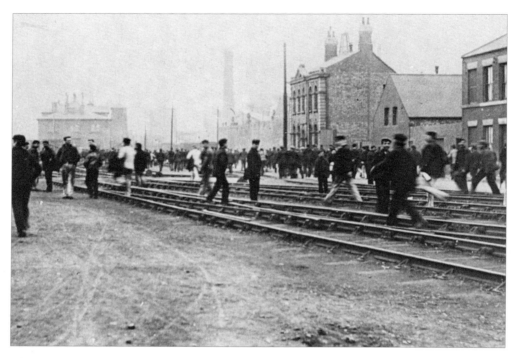

A busy scene of workers weaving their way to work over the railway tracks in the Ironmasters District, ready for the start of another shift.

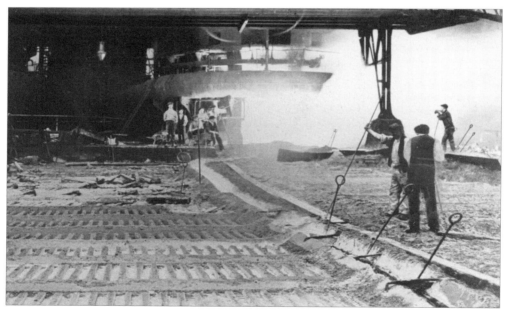

One can almost feel the heat in this local works where pig-iron is in the process of being cast.

Taken by a Middlesbrough photographer from a local industry collection, these views vividly capture the working man at work and rest.

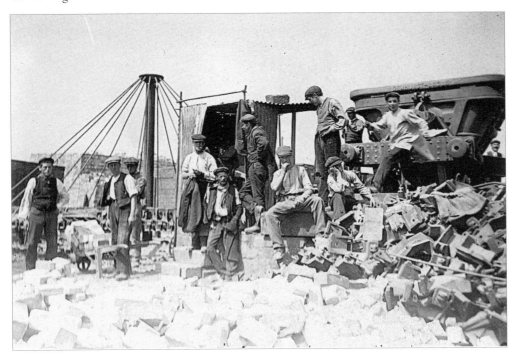

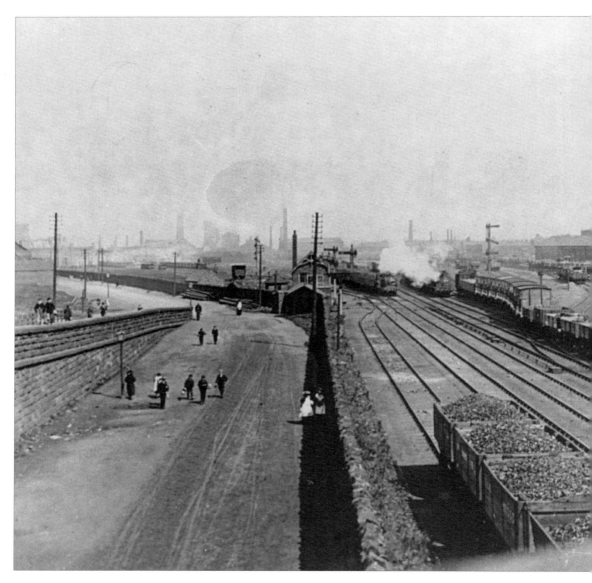

Busy railway lines in abundance, with the works, dominate this view of the Ironmasters District in about 1909. The road in this view is the Forty Foot Road, which has been trodden by all who worked in this area. Seen here, those at road level are heading for Fox-Head's Bridge, while those on the incline are approaching Metz Bridge, from which this photograph was taken.

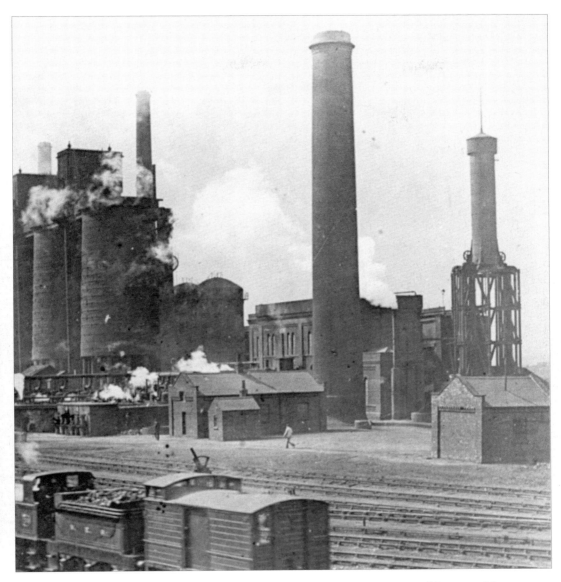

Another fine photograph from the 'local industry collection', *c.* 1912. A powerful image of the once mighty iron and steel works with their own rail links that littered the Ironmasters District of town.

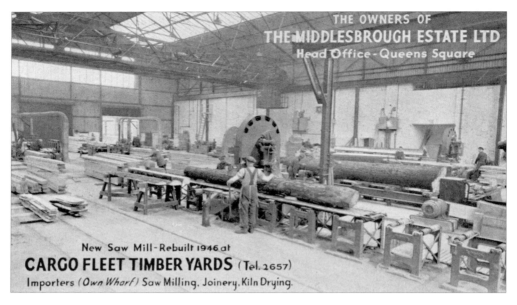

THE OWNERS OF
THE MIDDLESBROUGH ESTATE LTD
Head Office - Queens Square

New Saw Mill - Rebuilt 1946 at
CARGO FLEET TIMBER YARDS (Tel. 2657)
Importers (*Own Wharf*) Saw Milling, Joinery, Kiln Drying.

Timber yards were once a prominent feature of bygone local industry, and were found on both banks of the River Tees. A particularly powerful image of great change is seen in this view, as this yard stood on the site of today's Cellnet Riverside Stadium.

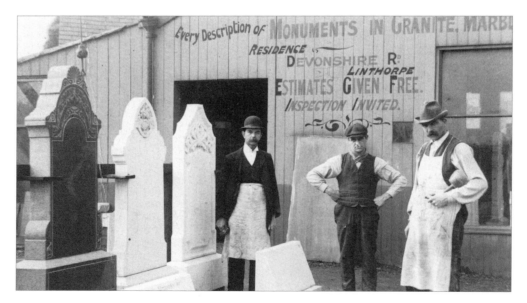

Many locally established small firms served the community's needs, such as Lords' Monumental Works, seen here in an Edwardian postcard view. Founded in 1860 and originally based in Newport Road, Lords' expanded and moved to the corner of Roman and St Barnabas Roads, where the business still trades under the same name. Seen in the photograph are Mr Alfred Lincoln Lord (in the bowler hat), a son of the founder, with the head mason Mr Binks (on the right) and his assistant.

SECTION FOUR

AROUND THE TOWN

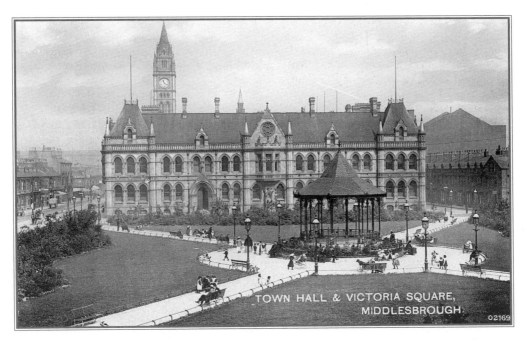

An Edwardian postcard view showing the original layout of Victoria Square with its central bandstand. The Town Hall, as now, dominates the north side of the square.

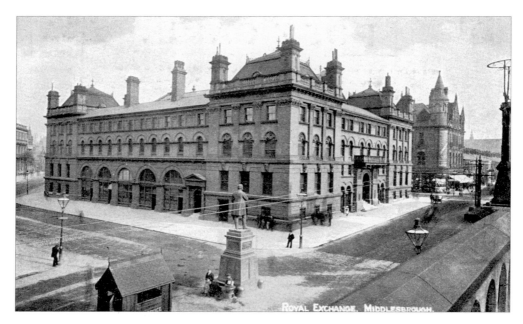

Once in the commercial heart of the town, the Royal Exchange building, seen here, had a commanding position at the corner of Albert Road and Marton Road. Demolished to make way for the A66 flyover, the Exchange was opened in 1868, having cost £28,000. The turreted building beyond still stands and was the original department store of Newhouse's which traded here between 1891 and 1912, before moving to what is now the Debenham's building in Linthorpe Road. The view below shows the Bolckow statue in its original position in Exchange Square.

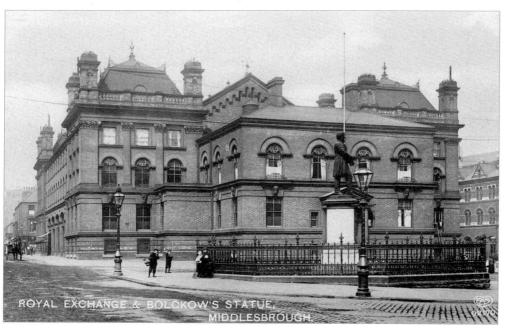

Standing in Wilson Street near to today's Exchange Square (looking in the opposite direction to the previous photograph), a group of children stare at the camera. Behind them, the buildings, from left to right, were once the Middlesbrough telephone exchange, the head post office, Jordison's the printers' original building and the East End Methodist Chapel. Only the post office building survives today.

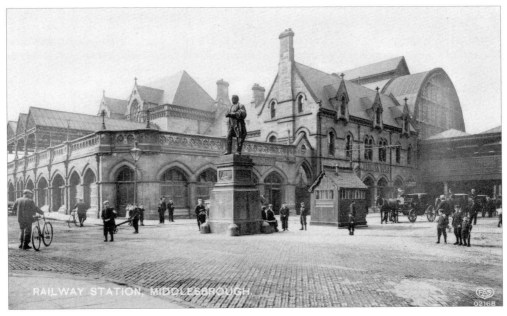

RAILWAY STATION, MIDDLESBROUGH.

This view of the railway station, opened on 3 December 1877, was taken looking back to where the top picture opposite was taken from. The arched roof seen in the photograph was destroyed during the Second World War. More recently, the station has undergone extensive restoration. The statue in the foreground is that of John Vaughan, which was originally unveiled on this spot in 1884. In 1914 it was transferred to Victoria Square, where it stands today.

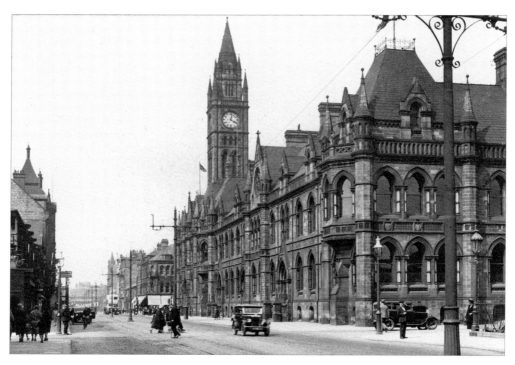

These two views show the Town Hall as seen from Albert Road. The Town Hall was opened on 23 January 1889 by the Prince and Princess of Wales. Much the same today, the building is a much-loved landmark. However, all the buildings on the left have made way for the Cleveland shopping centre and the eighteen-storey Corporation House.

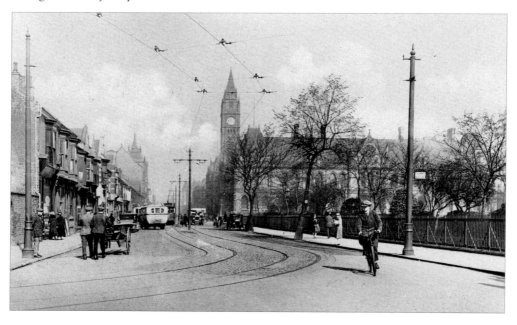

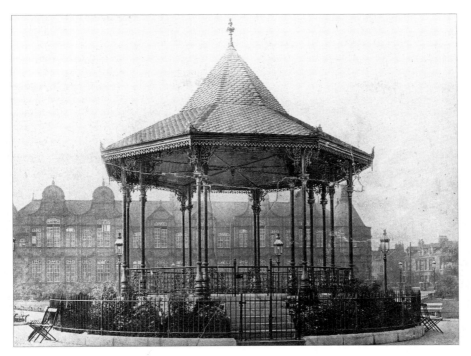

A close-up view of the Victoria Square bandstand, with the Hugh Bell Schools complex in the background. The square and bandstand were officially opened on 12 July 1901, with a concert by the Band of the Coldstream Guards.

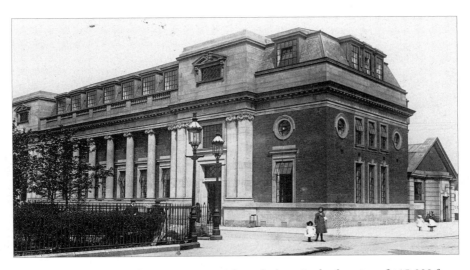

Opened on 8 May 1912, the new Carnegie Library had received a donation of £15,000 from the Scottish-American steel magnate and philanthropist Andrew Carnegie. The actual cost of the building turned out to be £16,423 and Mr Carnegie made a further donation of half of the excess, while the other half was raised by public subscription.

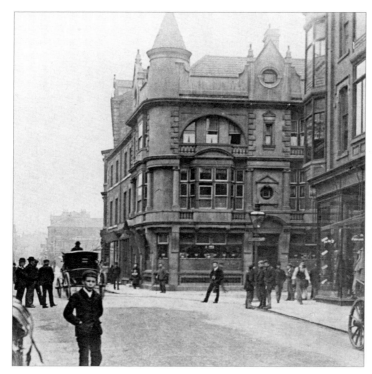

Rebuilt in 1894, the Leeds Hotel was a three-storey building with a stucco façade and a small turret. On the corner of Linthorpe Road and Wilson Street, it came to grief with several neighbouring properties as a result of enemy action during the twenty-second air raid on Middlesbrough, on 26 July 1942.

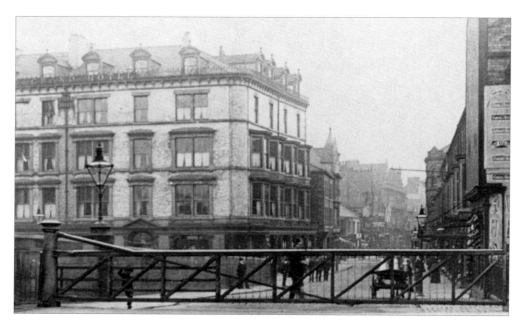

Facing the railway station and on the next block to the Leeds Hotel, the Grand Hotel suffered a fate similar to that of its neighbour during the same air raid. Only a small part of the building survives today.

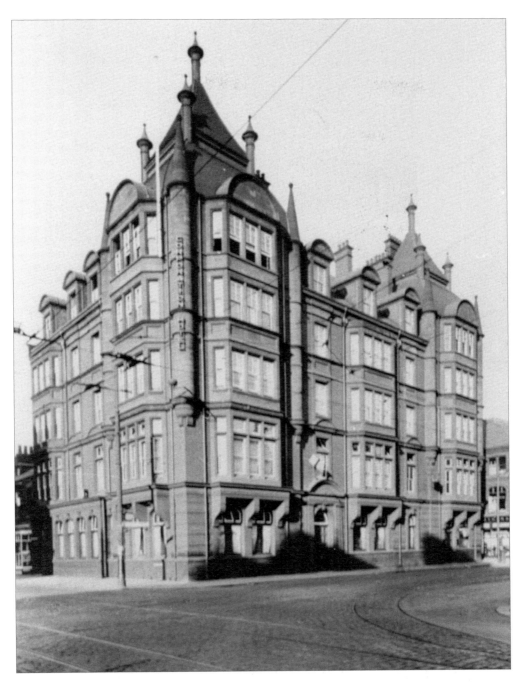

Commanding a prominent position at the junction of Corporation Road and Albert Road, the Corporation Hotel, an imposing Edwardian building, was once Middlesbrough's leading residential hotel. These premises were completed in 1905, having replaced an earlier building which was first licensed in 1863. The hotel was demolished in 1971 and Corporation House, a large office block, now stands on the site.

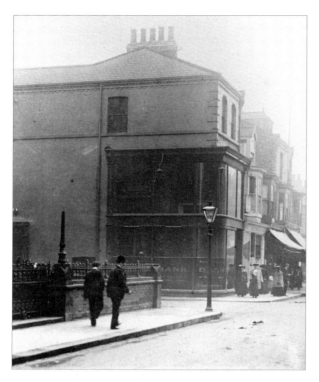

Taken in about 1904, this view of Linthorpe Road at its junction with Wesley Street is of an era long gone. Nothing of these buildings survives today, being where British Home Stores joins the Cleveland Centre. In the Edwardian photograph the low wall on the left belonged to 'Big Wesley', now the British Home Stores building. The then National Provincial Bank had just recently taken the premises from Miss M.E. Thomas's emporium. The bottom photograph shows the same bank at no. 68, with J.E. Green's, ladies' tailor, at no. 70 and T.W. Thompson, a jeweller, at no. 72.

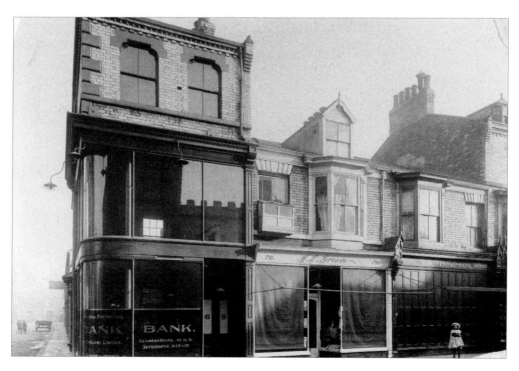

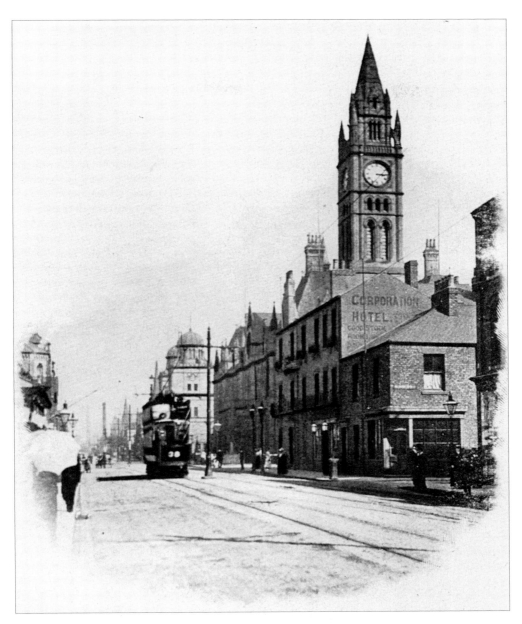

Reflecting continual changes and improvements in Middlesbrough's commercial centre, this turn-of-the-century photograph shows the recently opened Empire Music Hall, the Town Hall clock tower and a gleaming electric tram passing the original Corporation Hotel, shortly to be replaced to plans approved in 1901 for a new hotel.

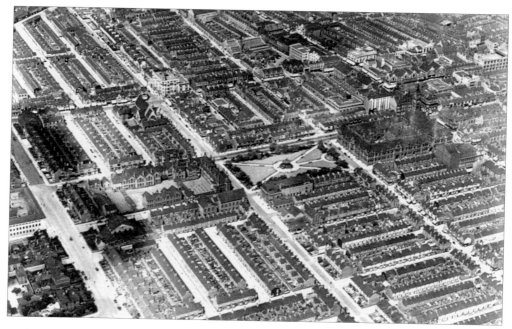

Looking westward across the heart of town, the Town Hall, Victoria Square and the former Hugh Bell Schools take centre stage. The vast majority of the tightly packed terraces have now gone and only a few of the larger buildings survive.

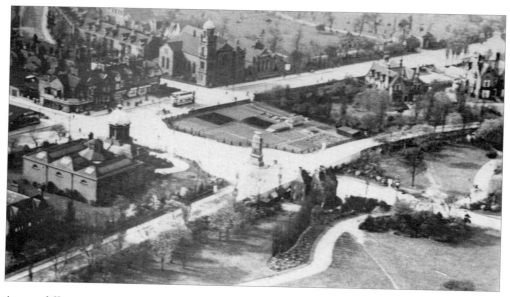

A very different view of the park gates and Cenotaph. This early aerial view is quite unusual. The distinctive Park Wesleyan Chapel adjoins the old cemetery and St Aidan's Lodge still stood in its own private gardens, now replaced by the university halls of residence.

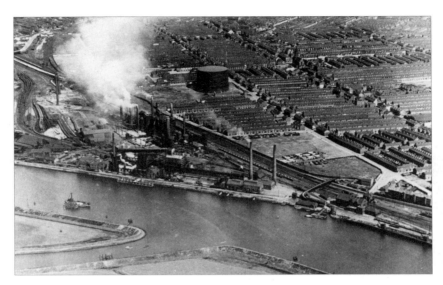

A late 1920s view of the Newport and Cannon Street area of the town. Cannon Street can be seen running diagonally past the gasholder and Newport Road is discernible running parallel beyond. At the bottom right of the photograph are the Hustler Granary, the Newport railway station and the eventual site of the 1934 Newport Bridge.

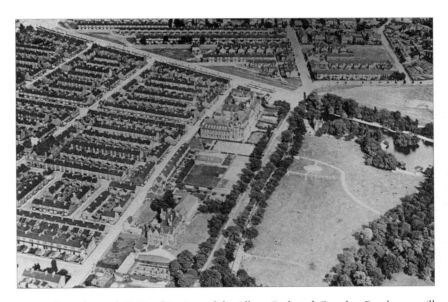

Dating from the mid-1920s, this view of the Albert Park and Croydon Road area will be of special interest to Boro' football fans, as it offers a rare view of the site of the original ground. The football club's first two seasons were played here on the park's Archery Ground. Other prominent landmarks include Parkside maternity hospital and Nazareth House. Note also that there are no houses on the east side of Croydon Road and yet-to-be-filled gaps in Newstead Road.

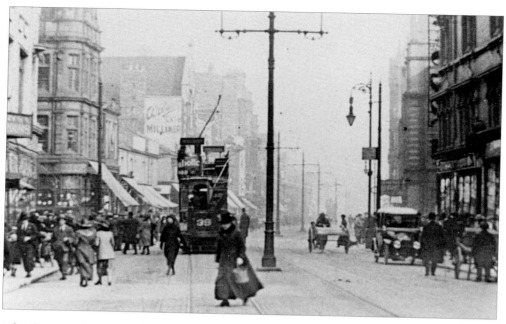

A bustling pre-1914 scene where Newport Road meets Corporation Road in the heart of the town's shopping centre. An electric tram and motor car had plenty of room in those days, but now the trams have gone and cars have only limited access to this area.

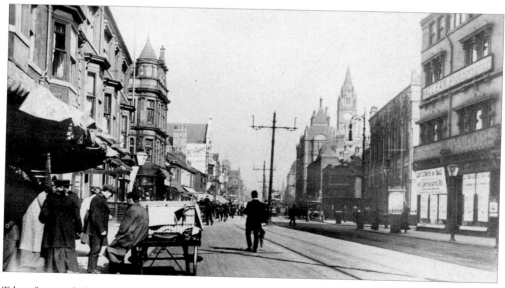

Taken from a slightly more distant viewpoint in 1911, this picture shows the same roads as in the view above. The old King's Head Hotel is on the left, and Collingwood's, Saltmer's, 'Cheap' Wilson's and Baker Brothers were the names of some of the shops trading in this area which had substantial custom at that time.

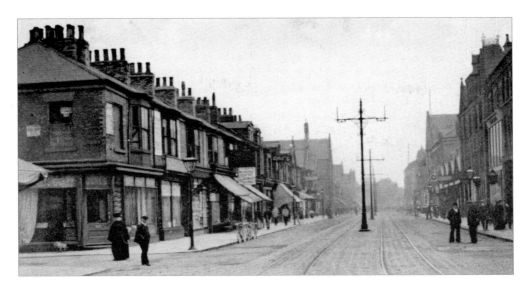

Newport Road, with Dale Street off to the left. In the distance the outlines of two bygone churches can be seen. On the left was the United Presbyterian Church which, in 1919, became the Scala cinema and, on the right, Newport Road Baptist Church which was demolished in 1936, along with its neighbour, the Cleveland Hall, to make way for the former United bus station.

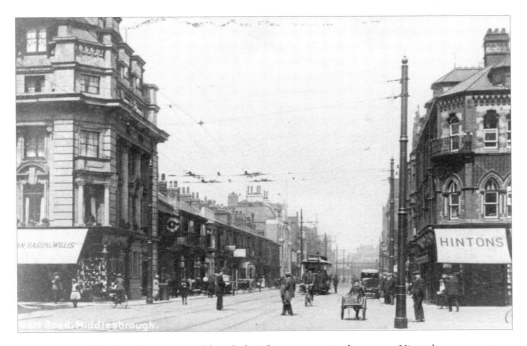

The two corner buildings here survive, although their former occupiers have gone. Hinton's, a grocery store and café founded by Amos Hinton, is now occupied by the Midland Bank, while Freeman, Hardy & Willis, the shoe shop on the opposite side of the road (see p. 73), now houses the Darlington Building Society.

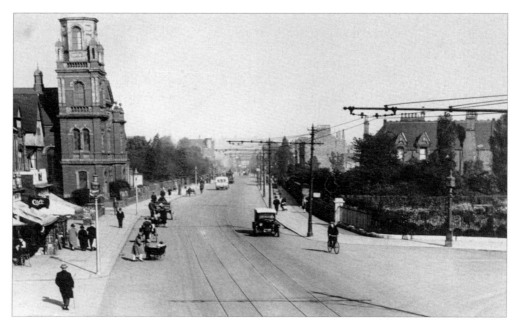

Changes have taken place here, near the entrance to Albert Park. Looking along Linthorpe Road, Park Wesleyan Chapel, on the left, is still standing, but is now closed. The trees beyond are now part of Ayresome Gardens, but were then the boundary of a cemetery. St Aidan's Lodge, on the right, was demolished in 1970 and the long-gone tram lines were last used on 9 June 1934.

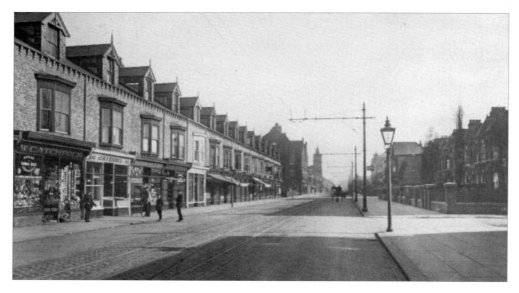

Continuing to look northwards along Linthorpe Road, the terrace of shops on the left were built on the former Linthorpe Road football ground, first rented to the club secretary in 1882 as 'a field and a shed'. The walled gardens on the right are of Seaton Terrace, much changed today.

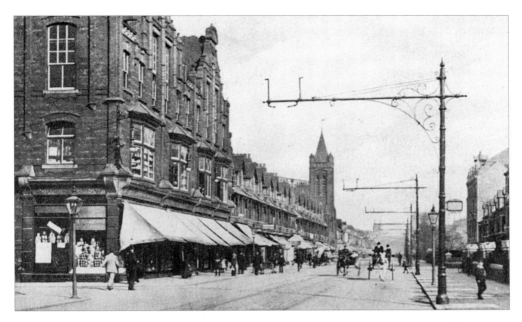

Further along Linthorpe Road, this view shows the Co-op Emporium on the corner of Clifton Street, which, with its second-floor Victoria Hall, was destroyed in the air raid of 25 July 1942.

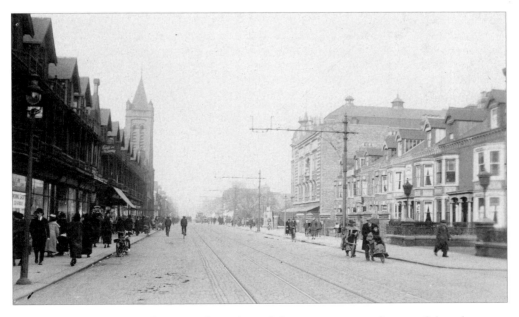

Still in the same part of Linthorpe Road, just beyond the emporium, was the row of shops known as St George's Terrace, built in 1908, and St George's Congregational Church which opened in 1894. On the opposite side stands Ashburton Terrace, dating from the 1890s and still surviving, although altered in parts. The Grand Opera House occupied the site on the corner of Southfield Road.

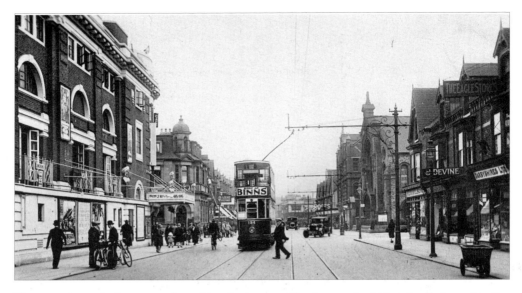

This scene is much the same today, with only the street furniture and vehicles visually betraying that this is the 1920s. On the left, the Elite cinema (later the ABC) had replaced the Immanuel Baptist Church in 1923. Still a home of entertainment, the building is now the Crown bingo hall.

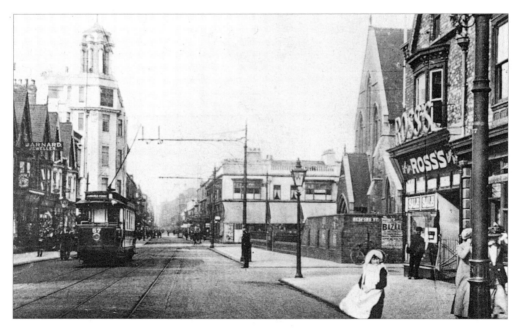

Looking towards the block where the Cleveland Centre is now situated, All Saints Church is on the right, just beyond Ross's clothing store at the corner of Bedford Street. Other than a tram passing Wright's Tower House (see p. 75), there is little activity in an area where there are now usually throngs of people throughout the day.

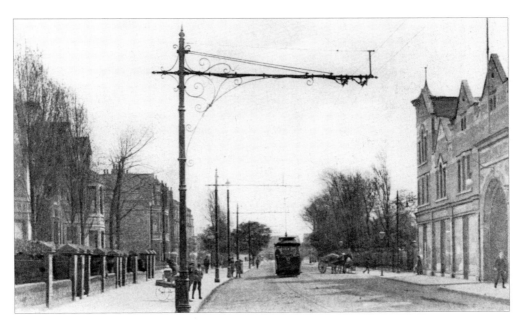

This view is looking down Linthorpe Road near the Forbes building of 1900. Grosvenor Terrace has a very suburban appearance, on the left, with Park Terrace beyond. It was here that John Newhouse, the founder of Newhouse's department store, lived until his death on New Year's Eve, 1910.

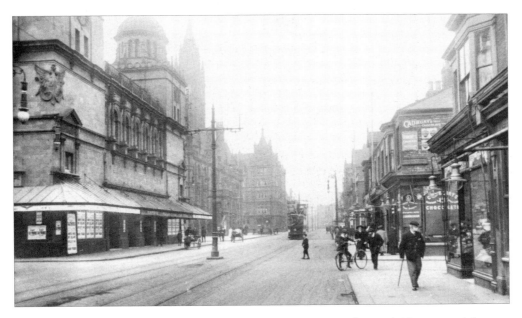

The distant tram, passing the Town Hall, heads along Corporation Road towards Newport and then out of the borough to the terminus at Norton Green. On the left is the Empire music hall and small shops line the road on the right. Only the Town Hall and the Empire still stand today.

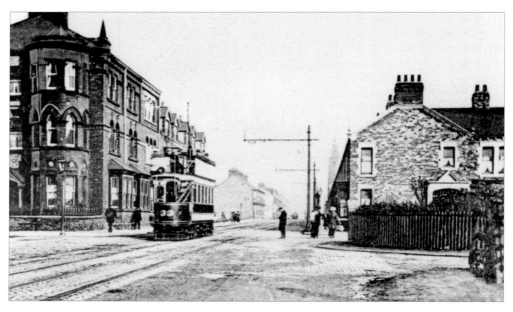

An open-topped electric tram passes the junction of West Lane with Newport Road as it heads towards the town centre. It was from this point that the Mayor of Middlesbrough, Alderman Thomas Carter, ceremonially drove the first electric tramcar to Middlesbrough Town Hall on 16 July 1898.

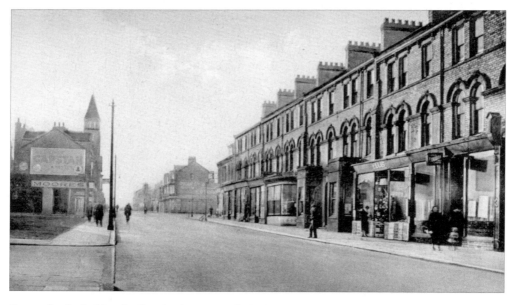

Except for St Cuthbert's Church (the tower of which can be seen on the left) all the buildings in this view are long gone. This is Newport Road looking towards the approach to Newport Bridge, which is the gap past the buildings on the right. Known as the Tees Bridge Approach, one side each of Samuelson Street and Calvert Street was demolished to create the bridge entrance.

SECTION FIVE
STREETS & HOUSES

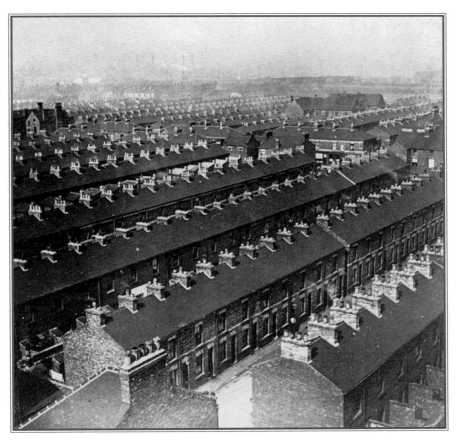

A unique view taken from the tower of St Paul's Church looking northwards over the rooftops of the terraced houses of the Newport / Cannon Street area. Sadly, nothing now remains of this once thriving community.

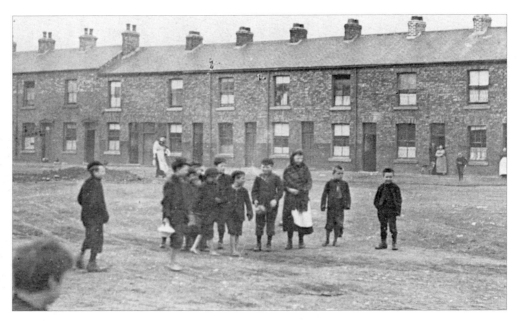

These children, some barefoot, are eager to be photographed, even in these drab and mean surroundings. The terraced houses behind are typical of the type built in the Newport area between 1860 and 1880.

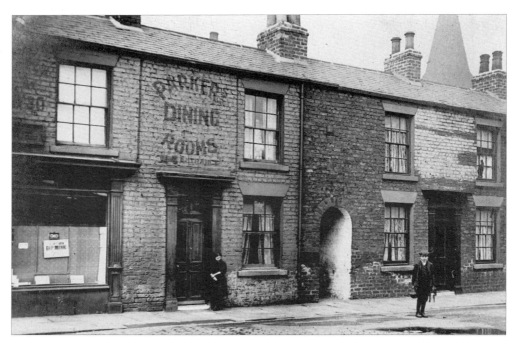

This pre-1914 photograph shows the Parker Dining Rooms, located at 34 Bridge Street East. Peeping above the rooftops is the spire of St Peter's Church which was destroyed in a bombing raid in 1940.

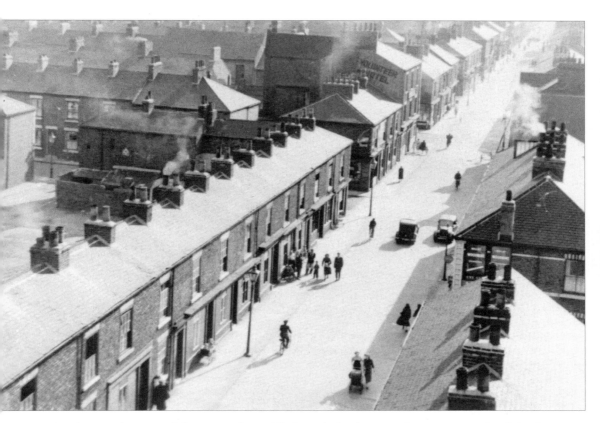

This photograph is one of the rarest of a Middlesbrough that has gone forever. Known by all local inhabitants and home to many, Cannon Street was a tightly knit community that has been totally obliterated by the planners. Taken in the early 1930s from the tower of St Columba's Church, this view looks up Cannon Street in a westward direction. The slightly taller building, towards the top of the street on the left, was the Volunteer Hotel, on the corner of Cannon Street and Denmark Street.

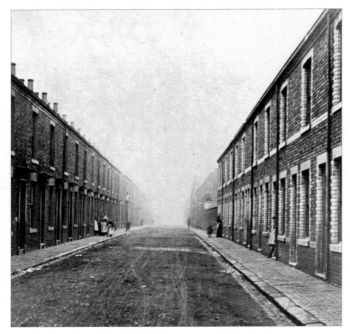

A typical street off Cannon Street. These houses survived until their demolition in the 1960s. This is Lawson Street with St Patrick's Infants and Junior School just visible on the right. The school was opened on St Patrick's Day 1873, and closed in 1963, when its remaining pupils were transferred to Marsh Street School.

No worries about traffic in Beech Street for these two tradesmen who seem oblivious to all around, as do the children seen here. The bay-windowed properties in the far distance are on Marton Road, with the acutely angled Borough Hotel, dating from 1867, on their left. Only the Borough Hotel (now the Malt Shovel) and the two tall buildings at the end of the street stand today.

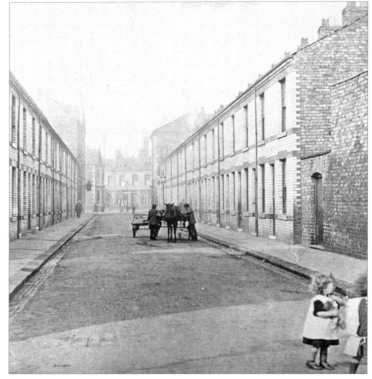

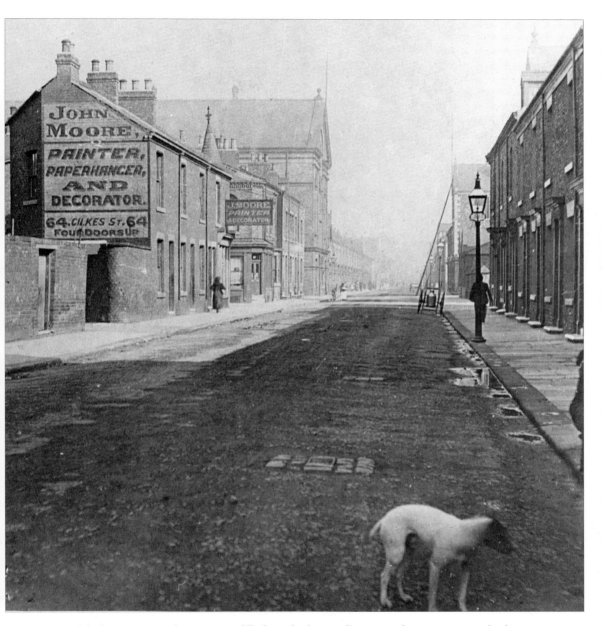

One of the larger streets of Victorian Middlesbrough, this is Gilkes Street disappearing into the distance to connect with Linthorpe Road. Prominent on the left is the Temperance Hall at the corner of Baxter Street, later to be converted to the Marlborough cinema. A long ladder is propped up against the Green Tree Hotel, the only survivor in this photograph, all else having been demolished.

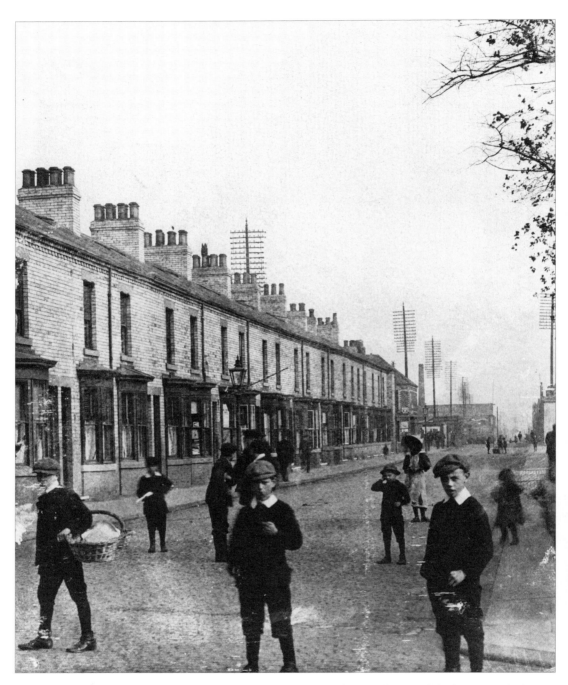

Proud to be in the picture, these children stand in the middle of Cargo Fleet Road, looking towards the level crossing on the Middlesbrough to Whitby line. Today, this is one of the pedestrian routes to the new football stadium. Now all gone, these bay-fronted houses were slightly more substantial than the flat-fronted terraced properties in the area.

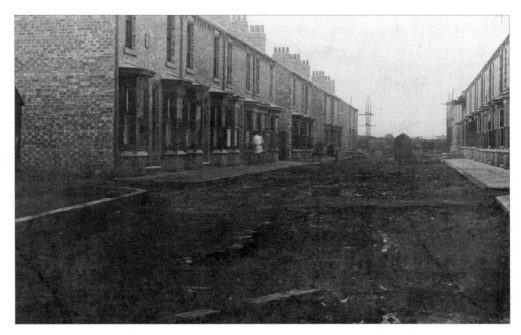

These two images show vividly the 'raw' and the 'finished' product – brand-new houses. Taken in 1909, Meath Street is seen under construction in the rare Edwardian photograph above. Brompton Street, built at about the same time, is seen below, in 1910, in its finished state, with the 'superior' terraced houses which replaced the flat-fronted ones of the Victorian era.

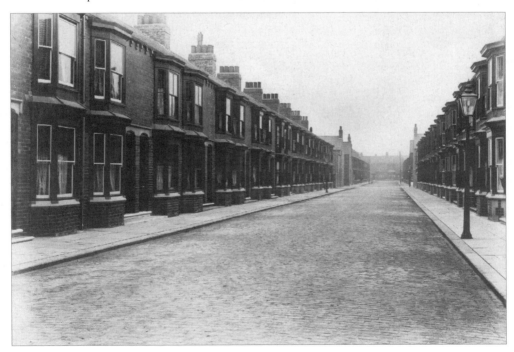

The town was not all mean and small terraces, as this and the remaining photographs in this section will show. Still residential in this 1890s view, this grand house (the end of a terrace) stood on the corner of Grange Road and Albert Road, then an expanding part of the town. Now in the heart of the commercial centre, the site of this property is occupied by the ramp leading to the Cleveland Centre car park.

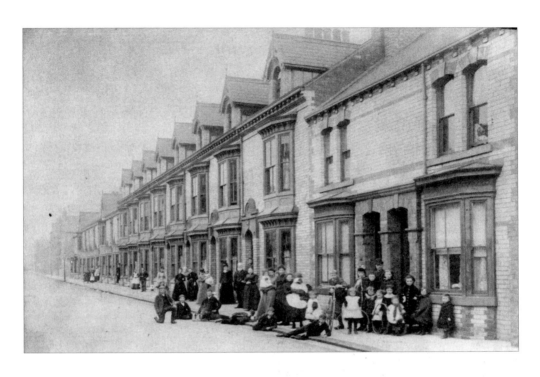

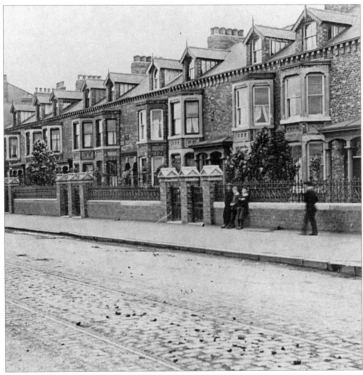

Above: Not too far away, off Grange Road, was Lennox Street, seen above with some of its proud residents posing for the camera in this late Victorian photograph. Built in stages during the late 1870s and early 1880s, Lennox Street ran between Borough Road and Grange Road. The view shows the east side looking towards Grange Road.

Left: A closer view of Ashburton Terrace (see the lower photograph on p. 53) shows late Victorian middle-class houses at their best. Built in the 1890s between the Grand Opera House (later the Gaumont cinema) and the Empire Hotel, only three of the original frontages survive.

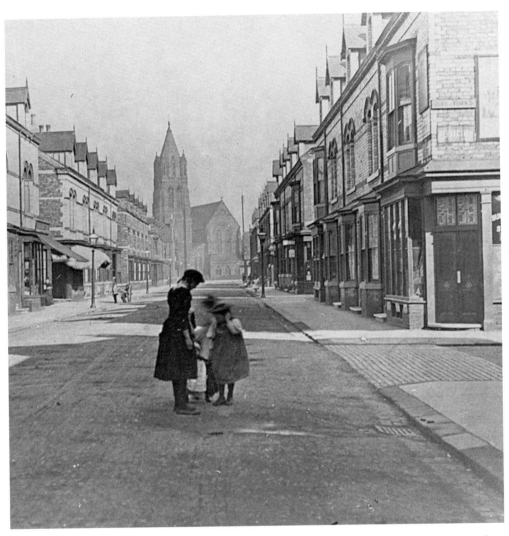

St John's Church terminates the vista of Russell Street in this turn-of-the-century photograph. Built in the 1870s, these houses were three storeys high and accommodated the families of skilled artisans and the lower middle class. The shop on the right was on the corner of Duke of York Street. The girls in the middle of Russell Street would have been quite safe, as they would have had plenty of time to get out of the way of the odd horse and carriage. Today, Russell Street is 90 per cent pedestrianised and it is still possible to stand where these girls were and see the church, but, sadly, all the houses were demolished in the 1970s.

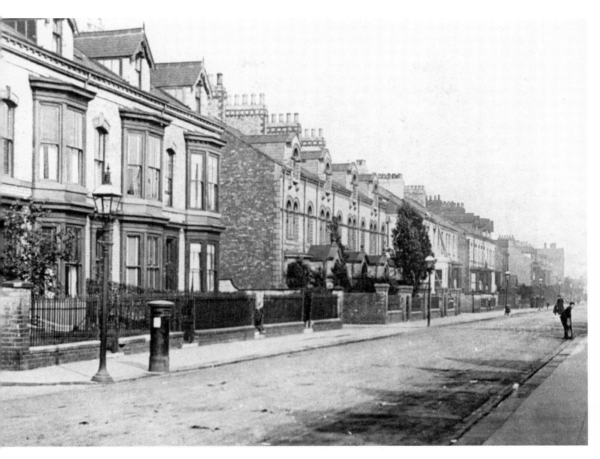

Complete with attics and basements, these rather dignified middle-class dwellings were built in the 1870s and lined the north side of Grange Road. Once a main thoroughfare, linking Hartington Road in the west with North Ormesby Road in the east, it was one of the more majestic of Middlesbrough's roads. Today the road has been split into five separate parts, with only three of the original terraces still surviving, one in Grange Road West and two in Grange Road East.

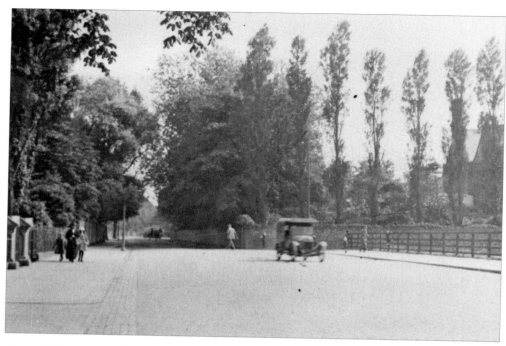

A very leafy Marton Road before it was widened here at Grove Hill. Gateposts on the left mark the entrance to Cleveland Villas, while Highfield House, dating from 1874, is on the right. Once the home of Edward W. Swan, an iron and steel merchant, it was converted into the Highfield Hotel in 1929. Below is a rural-looking Douglas Street in 1910. Running parallel to Marton Road, between Longlands and Borough Road East, many of the buildings on the street were stables and outbuildings of the large houses on Marton Road.

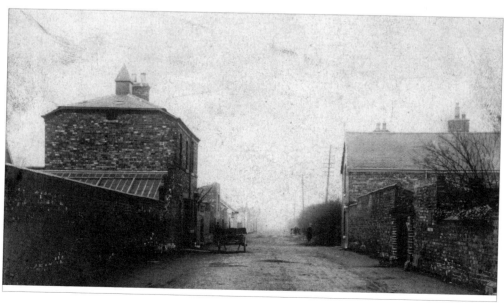

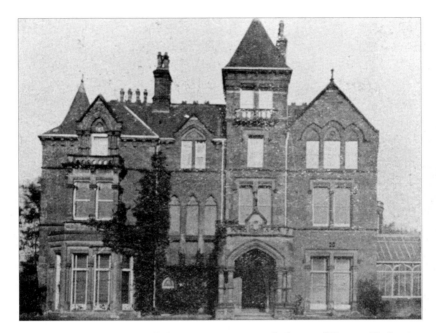

The house above was originally known as Grove Lea, the home of Herman Harkewitz, a German immigrant iron and steel merchant. In 1885, it became the official residence of the Roman Catholic Bishops of Middlesbrough until the 1950s, after which it became St Joseph's social club. Ironically, part of the property reverted to German ownership when the German firm of Aldi opened a supermarket within the former grounds in June 1995. Another of the 'grand mansions' of the Grove Hill area was the property below which was still standing as late as March 1996. When it was built in 1878, the road which is now Belle Vue Grove was its private drive. Named Brynteg, it was once the home of Thomas Henry Richardson, company secretary of Bolckow & Vaughan. For more than forty years prior to its demolition, the building was part of St Luke's Hospital complex.

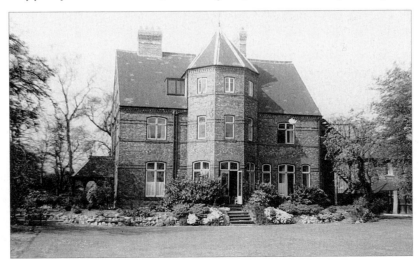

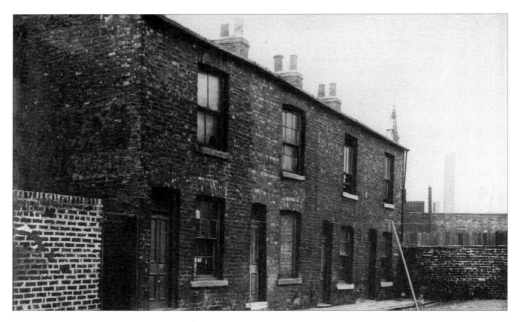

The houses above which show clear evidence of subsidence were in Bulmer Street, in the 'marsh' area of Cannon Street. Built of poor-quality materials on badly drained land, the houses were demolished shortly after this photograph was taken in 1910. It was from jerry-built houses like these that working people moved to the new council estates such as Grove Hill and Brambles Farm, shown below. These houses, at the corner of Berwick Hills Avenue and Kedward Avenue, offered superior homes at subsidised rents, with gardens front and back.

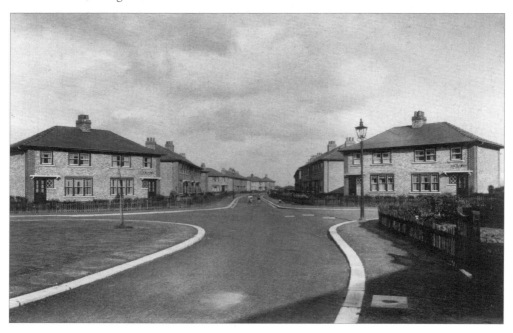

SECTION SIX
THE SHOPS

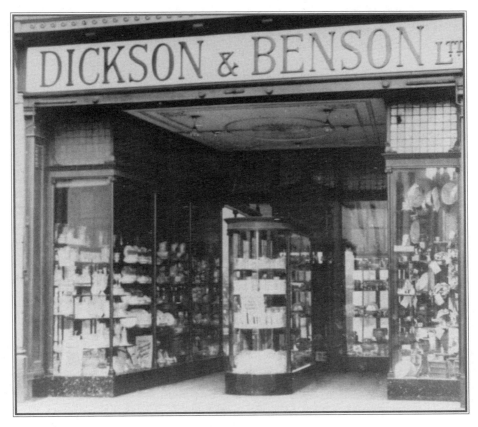

*Located at 38 Linthorpe Road, this distinctive Victorian shop frontage, shown here as the locally famous
department store of Dickson & Benson Ltd, was purchased during the 1940s by the equally famous local
firm of Newboulds, who still trade in the vicinity today.*

Once located in three sections in Linthorpe Road, Linthorpe Mews and Dundas Street, Dickson & Benson's was for decades a household name in the town. From a partnership formed in 1895, the business expanded to become one of the town's most prestigious department stores. The three sections were closely connected by an alleyway and the whole complex was destroyed by fire in June 1942, a blow from which the firm never fully recovered.

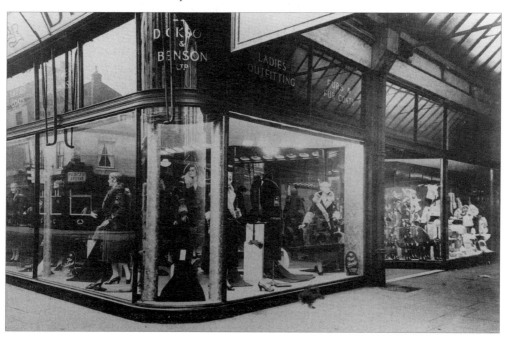

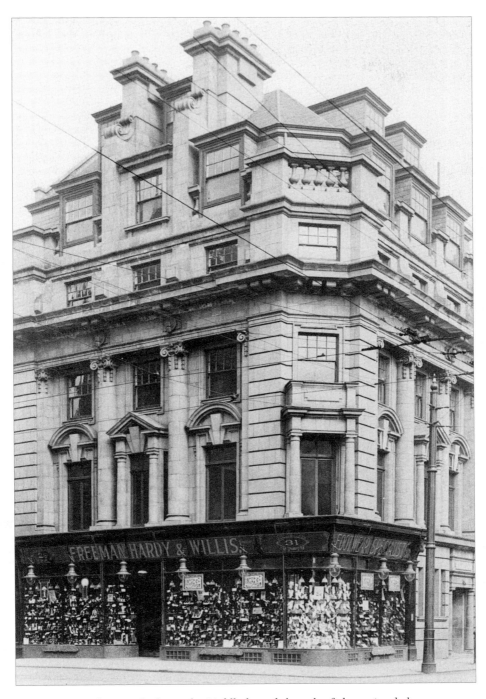

This pre-1914 photograph shows the Middlesbrough branch of the national shoe company, Freeman, Hardy & Willis. The top two floors have been removed, but otherwise the building, now occupied by the Darlington Building Society, remains much the same.

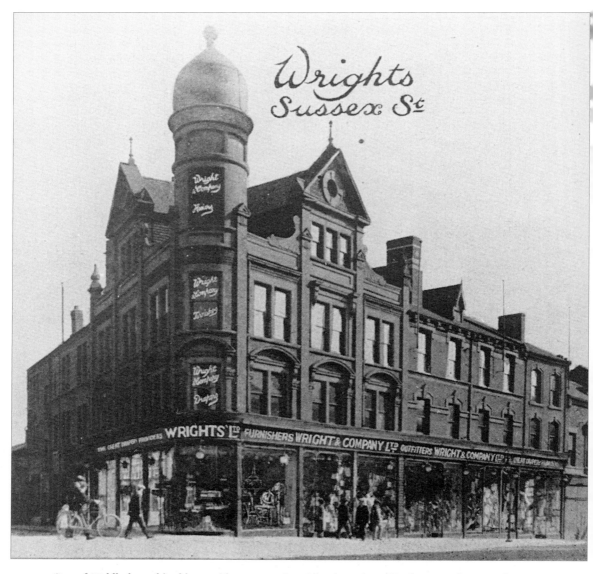

One of Middlesbrough's oldest and best-remembered local retailers, Wrights, was also one of its most highly patronised. These premises in Sussex Street were the company's main shop during the late nineteenth and early twentieth centuries until the opening of the Linthorpe Road store.

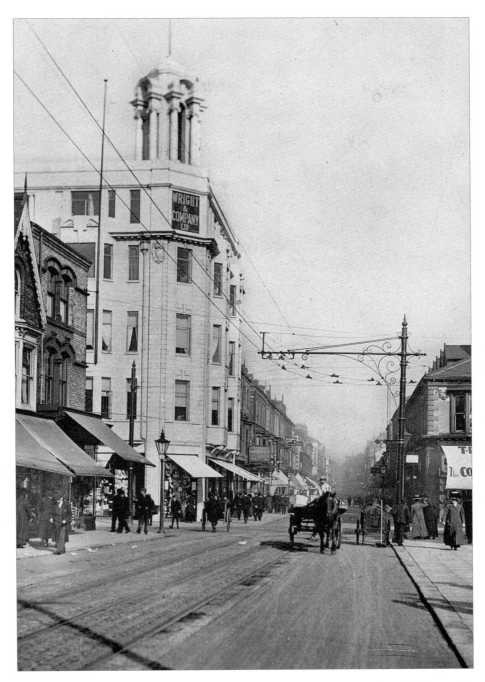

Wrights' Linthorpe Road premises, known as Tower House, were opened in 1910 on a site previously occupied by four large terraced houses which faced on to Grange Road. Even grander than the Sussex Street shop, this distinctive Edwardian building has been greatly missed since its demolition in 1986 to make way for a McDonald's burger restaurant.

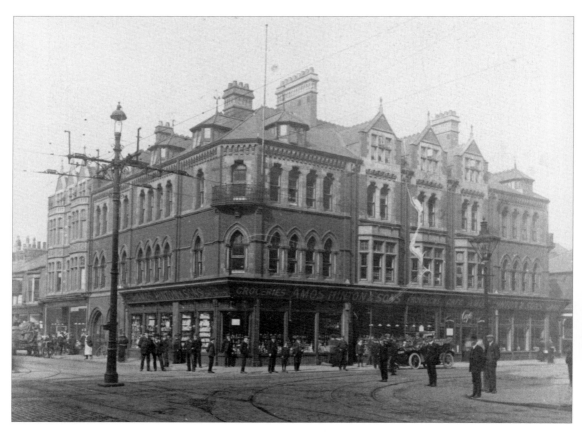

Hinton's, a local high-class grocer in the days before supermarkets, stood on this prominent corner site at the junction of Corporation Road and Albert Road, opposite the Town Hall. Building on this plot began in 1888, but it was not fully developed until about twenty years later. Although this remained the firm's home base, the company expanded to a number of shops throughout the area and was eventually taken over by Argyll Stores (owners of the Safeway chain). These premises are now the main Middlesbrough branch of the Midland Bank.

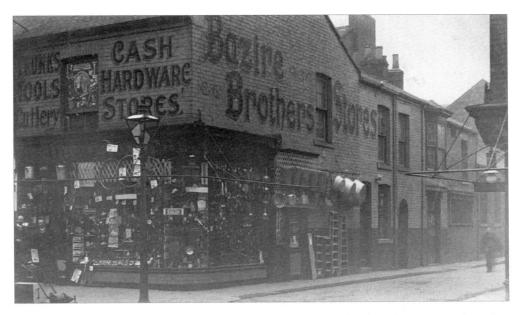

These two photographs show the same corner of Corporation Road and Linthorpe Mews, but taken fifty years apart. The lower picture, in which the street lighting has changed from gas to electricity, also shows that a small property to the rear of Bazire Brothers' shop has been replaced by much larger commercial premises. Bazire Brothers themselves seem also to have expanded their business by creating an upstairs showroom with a large window. The covered bridge which can be seen in the alley linked two of the sections of Dickson & Benson's.

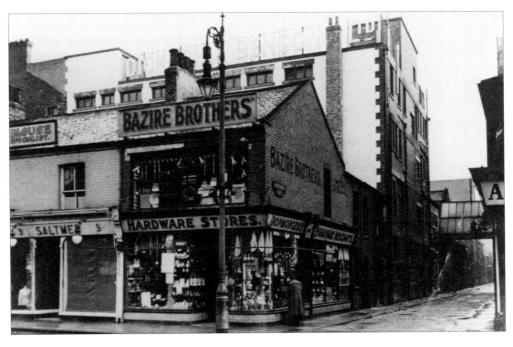

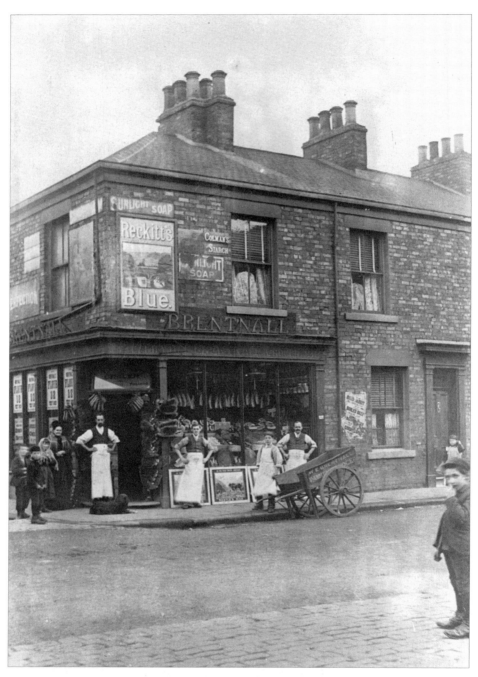

An evocative reminder of the days when corner shops were thriving, this is a typical general dealer's shop of the Edwardian era. The owner, William Elijah Brentnall, is standing proprietorially outside the shop door with his two assistants and errand boy. This shop was at 122 Cannon Street, but Mr Brentnall also had a shop at 31 Diamond Road, then a newer part of town.

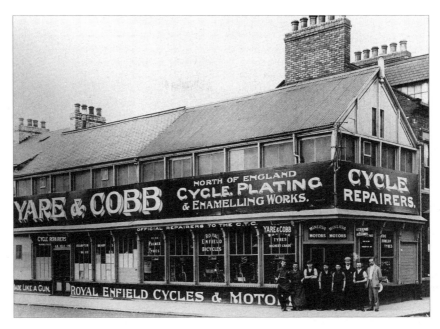

In 1889 G.M. Young advertised his cycle business in the supplement to the *Northern Review* which was published to commemorate the opening of the new Town Hall. By 1910 the premises at the corner of Russell Street and Bright Street had been taken over by Yare & Cobb. The building remained much the same until it went the way of most other property in the locality and was demolished in the early 1970s.

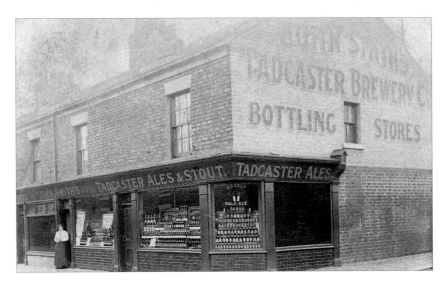

A well-stocked off-licence on Station Street, the first street off Linthorpe Road near the level crossing, shows the popularity of the liquor trade. This one seems to have expanded to take over some adjoining properties.

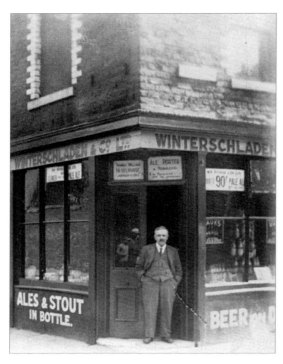

Thomas William Heslehurst, the manager of Winterschladen's off-licence at 37 Waterloo Road. Within living memory, the shop was distinguished by having a wooden golden cockerel placed outside the door. Winterschladen had many off-licences in Middlesbrough and the surrounding area, until taken over by Hinton's, before that company itself became part of the Safeway chain.

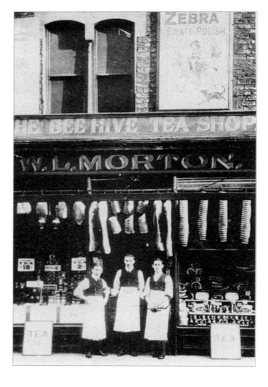

Another well-known small local trader was William L. Morton, a family grocer whose name and business continued until recent years. Shops such as his had their own atmosphere and a commitment to their local customers which the modern superstores cannot match.

SECTION SEVEN

ELECTRIC TRAMS

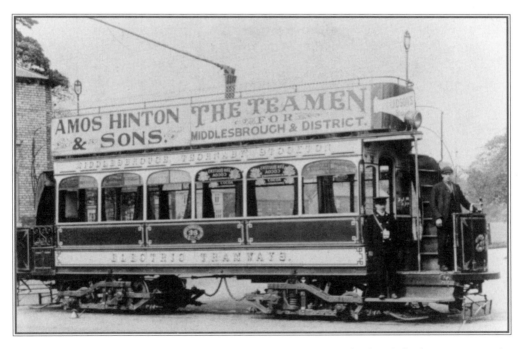

A new electric tram, seen here at its Norton Green terminus, standing prepared and ready for the journey to North Ormesby, via Stockton, Thornaby, Newport and Middlesbrough town centre.

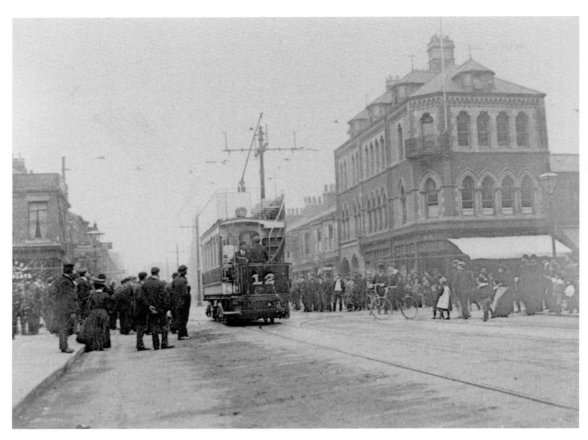

Crowds gather near the Town Hall to admire this gleaming new tramcar. Before being brought into service, a trial run was made on 21 May 1898, and it is possibly this occasion that the photograph records, as the vehicle is carrying no passengers. At this time, the Hinton's building which can be seen on the corner had not been extended to its final size.

Left: Again an empty tramcar, this time on the North Ormesby Road on a somewhat wet and dreary day. Maybe that's why there are no passengers; being exposed on the upper deck would put off most townsfolk.

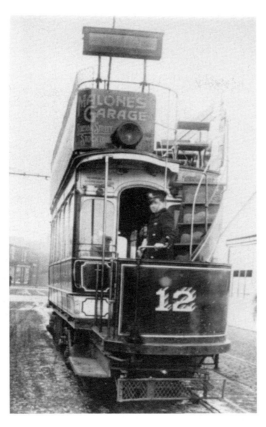

Below: These two tramcars passing the Town Hall seem to have attracted plenty of passengers, especially the one on the right. Maybe it's a special occasion, such as the opening day in 1898.

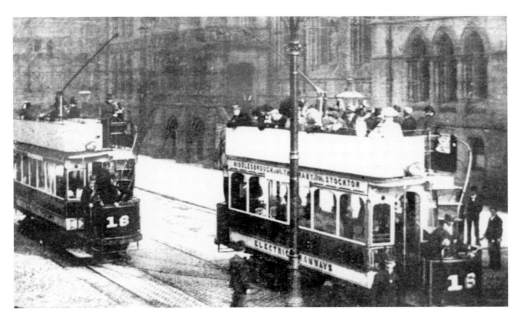

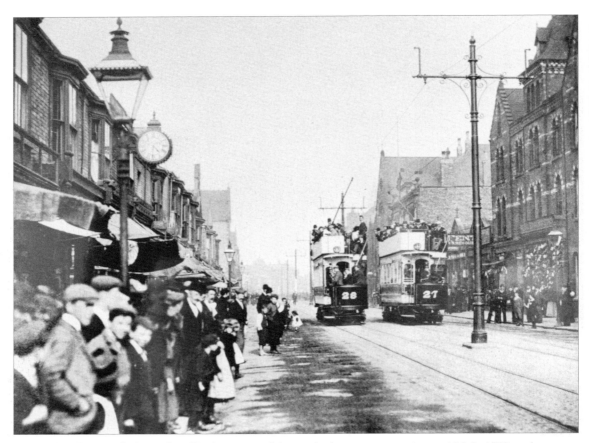

This photograph shows the official opening of the area's electric tram service on 16 July 1898, and a fascinated crowd has gathered to witness the event. This service replaced the former horse-drawn trams in Middlesbrough and steam trams in Stockton. The trams pictured are passing the site, on the right, of what is today's bus station in Newport Road. No. 28 is heading for North Ormesby Crossing, while no. 27 heads for Norton Green. As well as this route, another route from the Royal Exchange to Linthorpe Village, via Albert, Grange and Linthorpe Roads, commenced service on the same day.

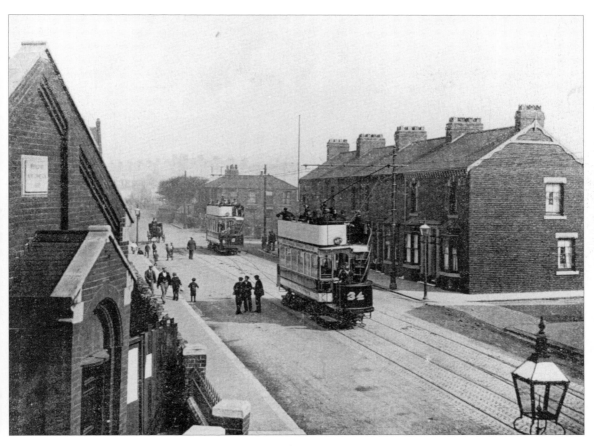

A memorable day for all! Hundreds of people wanted to try out the new mode of transport and trippers packed the trams all day. These two trams, which in the early days were known as 'motor cars', are near the North Ormesby railway crossing. The building to the right was the New Connexion Methodist Chapel which, like everything else in the picture, has failed to survive to the present day.

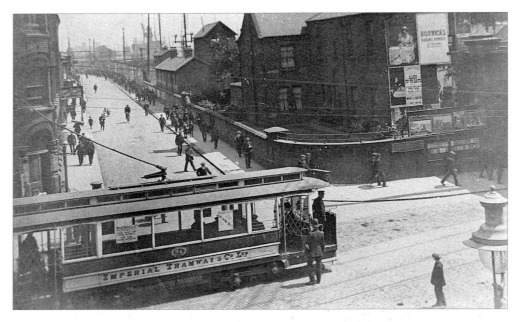

Coming off shift, workmen head home along Bridge Street East as an almost empty tram awaits its passengers. This tram is in Queen's Square, just before the Albert Bridge, en route to Linthorpe. Because of the low headroom of the bridge, this route was serviced by single-decker trams. Nowadays the most traffic that Bridge Street sees is on 'match days', when it is used by thousands of football supporters on their way to the new stadium.

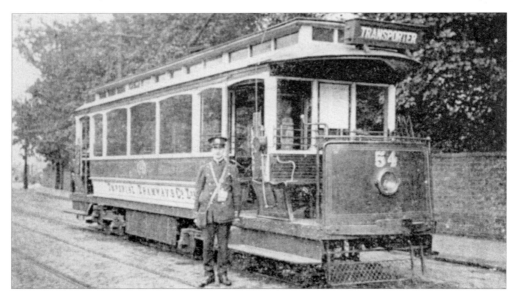

A conductor proudly stands beside his tram near the Linthorpe terminus, close to what is today the Linthorpe Hotel.

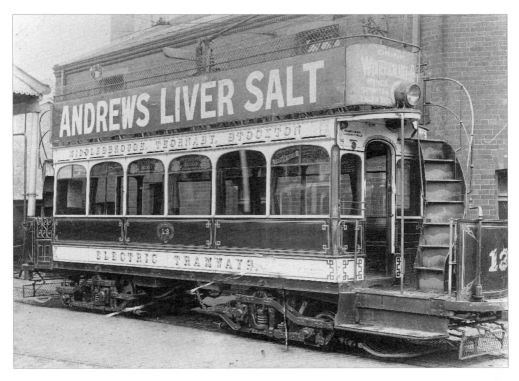

One of the early tramcars, resplendent in the livery of the Imperial Tramways Company, known locally as the Middlesbrough, Thornaby and Stockton Electric Tramways.

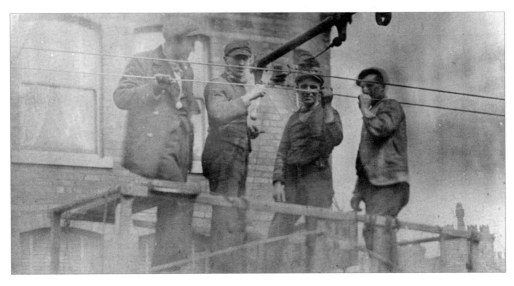

The only known photograph of local tramway repair workmen. Seen here in North Ormesby Road, they appear to be posing specially for the photographer.

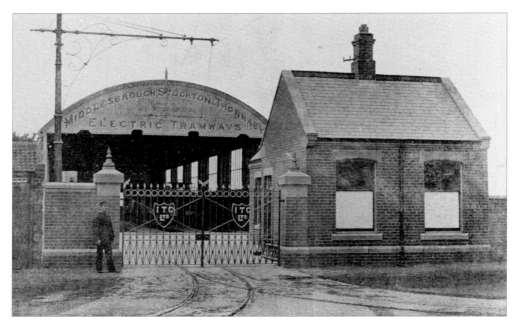

The tramsheds on Newport Road were built by the Imperial Tramways Company whose initials can be seen on the wrought-iron gates. The site, now adjacent to the Newport Library, had previously been used for keeping and grazing horses used on the old horse-drawn trams which ran to Newport ferry.

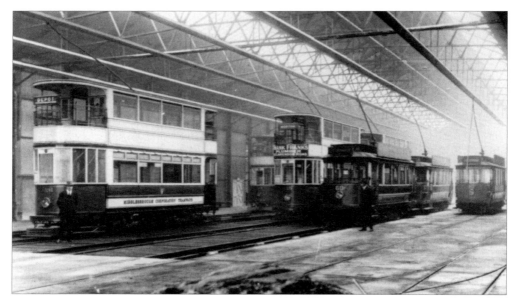

An inside view of the new Middlesbrough Corporation tramsheds which were opened on 19 July 1922 by Councillor Edwin Turner. The sheds were built by the Teesside Bridge and Engineering Company at a cost of £19,814.

SECTION EIGHT

CHURCHES & CHAPELS

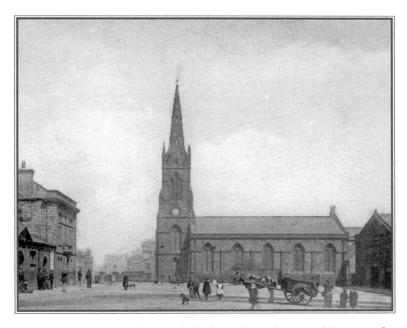

*Built mainly by public subscription on land given by Joseph Pease and the owners of
the Middlesbrough Estate, St Hilda's Parish Church stood partly on the site of an old
Benedictine priory. Completed in 1840 and demolished in 1969–70, the church is
shown here as it appeared from Market Square.*

Tucked away in the north-west corner of the Market Square, Middlesbrough's first 'modern' free-standing place of worship was the Centenary Wesleyan Methodist Chapel of 1838. Closed as a chapel in 1949, it was used as a shirt factory for ten years before its demolition in 1959.

This is the church building of the old cemetery, Linthorpe Road, which housed two chapels, one Church of England and the other Nonconformist. Opened in 1854, the cemetery was closed in 1950, followed by the demolition of the chapels at the end of 1961 at a cost of £41 1s. 7d. On 6 August 1964, the site was officially reopened by the then mayor as Ayresome Gardens.

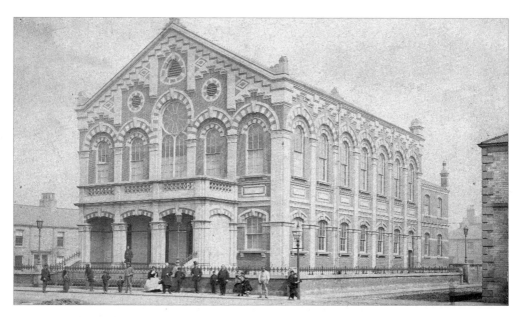

An 1860s photograph, the earliest known in existence, of Linthorpe Road Wesleyan Chapel, generally known as 'Big Wesley'. Possibly the town's best-remembered Methodist chapel, it opened in 1863 at the corner of Corporation Road, when the area was largely residential. An imposing building of red and white brick, it was closed in 1954 to become the site of British Home Stores.

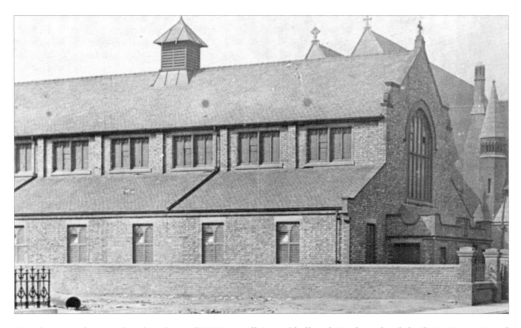

Seen here newly completed in the mid-1890s is All Saints' hall and Sunday school, built in Grange Road to plans passed in 1890. The site is today occupied by the fifteen-storey Church House.

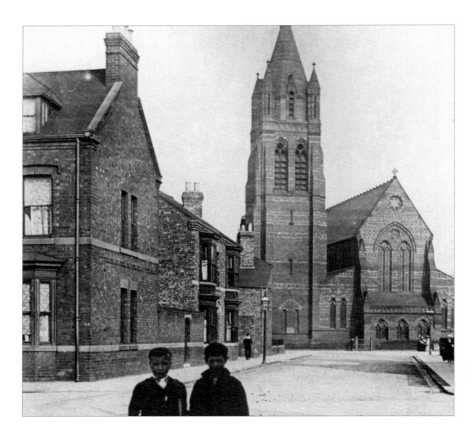

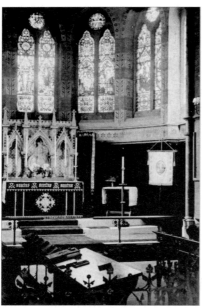

St John's Parish Church, dating from 1865, is now the oldest church remaining in central Middlesbrough. This view, taken from Russell Street, shows the original west elevation before extensions were added in 1914. The houses in the photograph are the only ones still surviving of the former Russell and Bright Streets. Pictured on the right is St John's original high altar with its Victorian reredos.

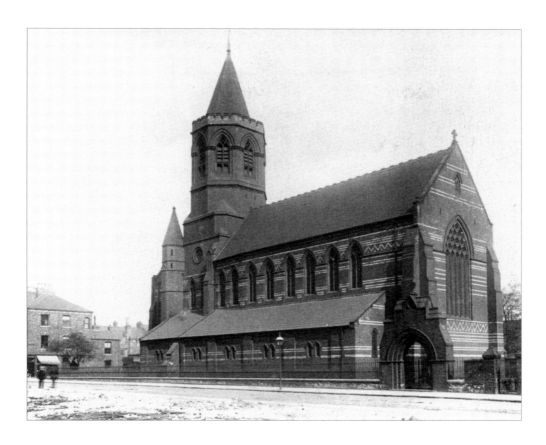

Another of the Middlesbrough churches which have succumbed to the demolition experts since the Second World War is St Paul's, Newport Road. Standing in the middle of the densely populated Cannon Street area, the church was built in the Decorated Gothic style during 1870–71, its foundation stone having been laid by Mrs W. Hustler on 25 June 1870, and its consecration taking place on 14 December the following year. The 63 lb cake, pictured on the right, was baked in 1931 to celebrate the church's diamond jubilee, but demolition followed only thirty-six years later, four years before it would have reached its centenary.

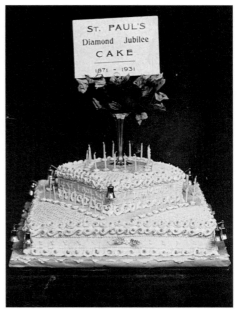

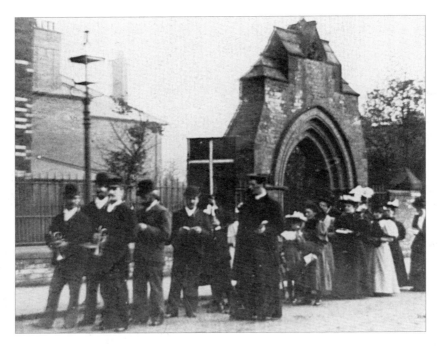

All turned out in their best attire, parishioners of St Paul's Church are forming a procession believed to be in celebration of Easter. The parade is led by some buglers and the ladies are wearing decorative bonnets. Having progressed along Newport Road (above) and turned into Lord Street (below), the procession is stationary near the junction with Petch Street. Behind the group, the Palmerston Hotel stands at the corner of Newport Road.

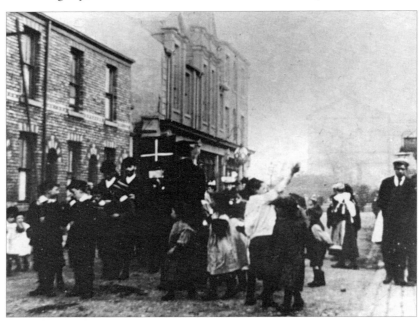

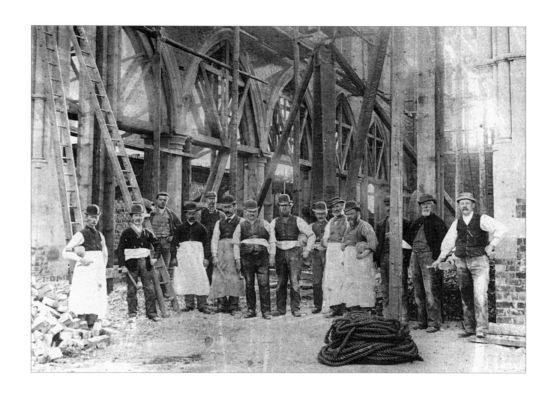

Above: Contrasting methods of church construction (see also the upper photograph on the next page): St Barnabas was a solid brick building first used for worship in November 1892 while still incomplete, with the official opening ceremony only taking place four and a half years later, on 2 June 1897.

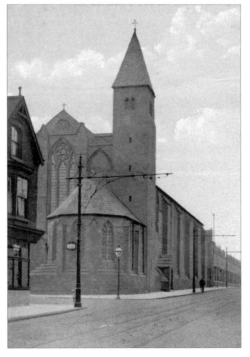

Left: A listed building, St Cuthbert's was designed by the famous ecclesiastical architect, Temple Moore. Consecrated in March 1901, the building today serves as a sports centre, although regular services are still held in the adjacent church hall.

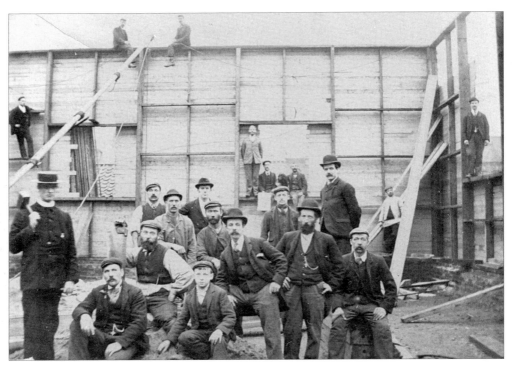

This picture shows construction work on the temporary wooden church of St Aidan, Linthorpe Road, which, when completed, as seen below, held its first service on 17 June 1899. The site was sold in the 1930s to Middlesbrough Co-operative Society, who built a department store upon it.

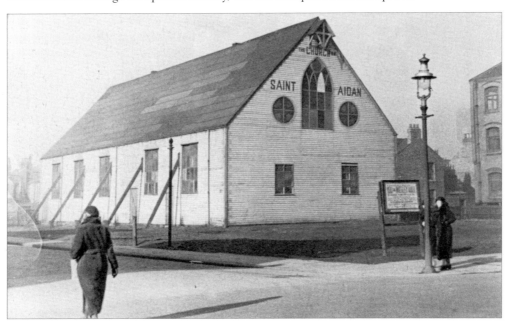

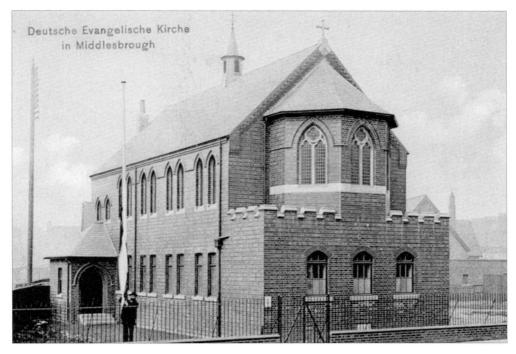

The first German-language church was established in Middlesbrough in 1882 by the Revd Johannes Sammert, before moving into the above church in Marton Road in 1901. Over the years the building has served as the Scandinavian Seamen's Church, a Brethren Gospel Hall and the St John Ambulance HQ.

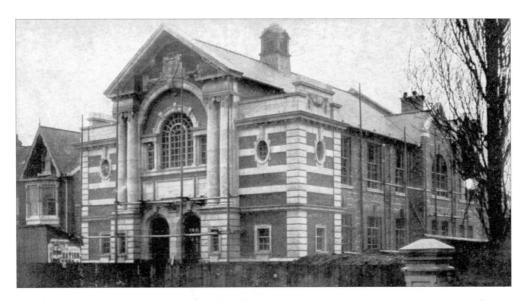

The distinctive Avenue Wesleyan Methodist Chapel was first used in 1908, its congregation having transferred from an earlier building at the corner of Simpson Street, which dated from 1860.

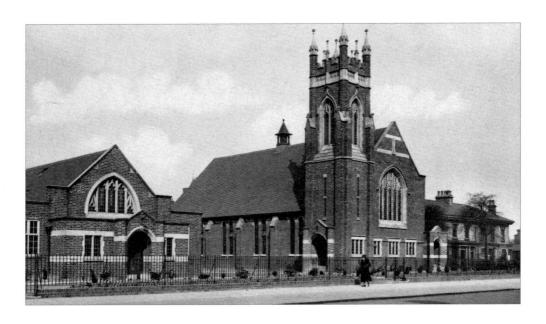

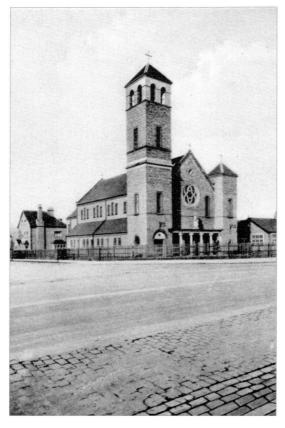

Above: Southfield Road Baptist Church had the distinction of opening on that rare date, 29 February, in the year 1928. After twenty-eight years (and only seven birthdays!) the building was found to be structurally unsafe and was closed on 1 April 1956.

Left: St Joseph's Roman Catholic Church, described as Romanesque in style, stands at the corner of Marton Road and Park Road South. It was opened in 1934 and consecrated in October 1958.

SECTION NINE
EDUCATION & HEALTH

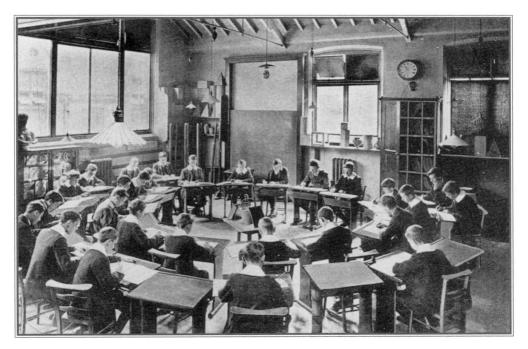

An Edwardian view of the Art Room in Middlesbrough High School. Less formal than normal classrooms of the time, the pupils nevertheless seem to be working diligently at their task.

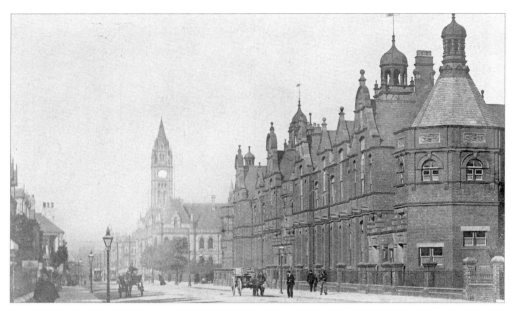

Looking north along Albert Road from Borough Road, the school buildings on the right opened originally as Grange Road Schools on 2 May 1892. In September 1900 the name was officially changed to Hugh Bell Schools. The site is now occupied by Teesside magistrates' courts, which were officially opened by Lord Hailsham on 2 February 1973.

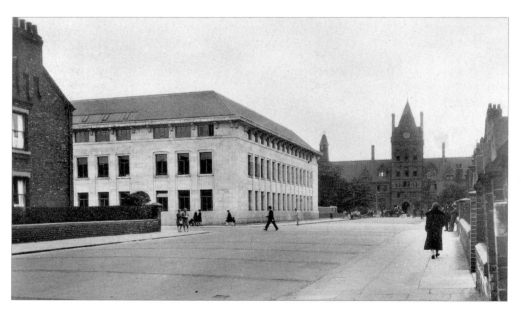

Looking away from Hugh Bell Schools, the former Middlesbrough High School and Constantine College stood on the other side of Borough Road. Although part of the old high school has been demolished, both of these buildings are still standing and form part of the University of Teeside.

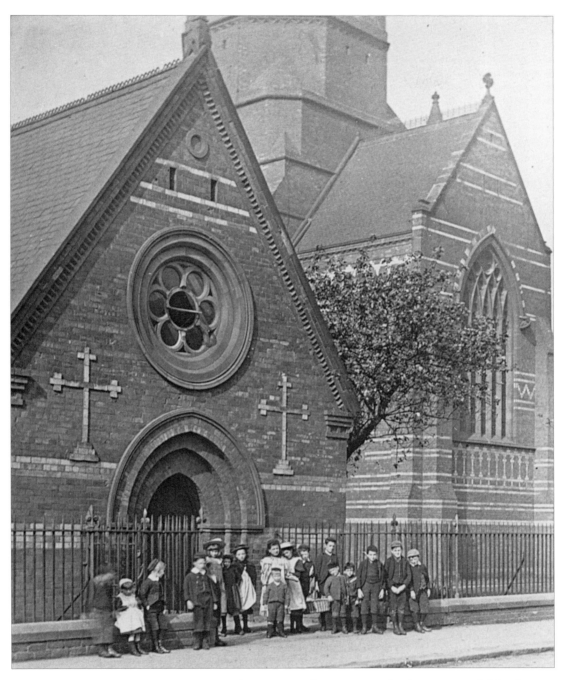

Before the passing of the Elementary Education Act of 1870, most schools were provided by the churches. These youngsters are standing outside St Paul's School which was opened in 1868 and occupied the whole of the block between the church and Lees Street. The school suffered some bomb damage during the Second World War and was finally closed in 1961.

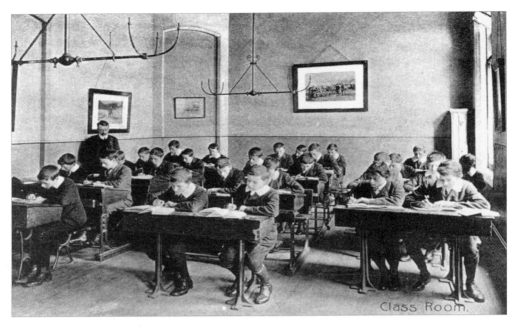

These high school boys study in pairs, while the girls sit at their single desks paying close attention to their teacher. High school education for boys had commenced in October 1870 at premises at 1 Grange Road, whereas girls had to wait for another twenty-four years before higher education became available at 37 Grange Road for those whose parents could afford it.

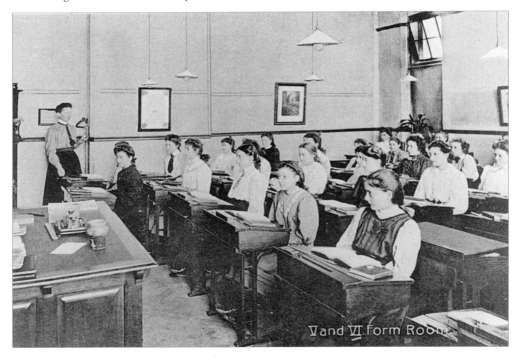

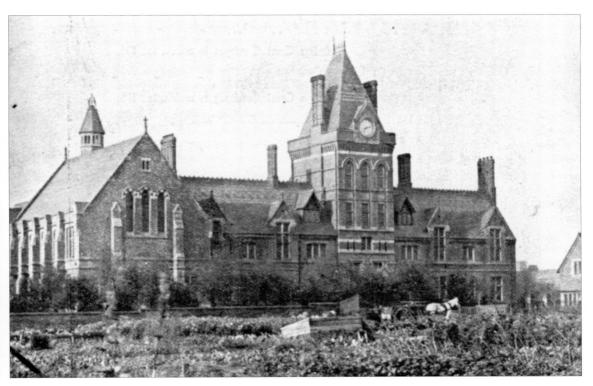

On land donated by the owners of the Middlesbrough Estate, the new Middlesbrough High School opened in 1877 on what would now be called a greenfield site. In a rare reminder of how the town has expanded in little more than a hundred years, the image above shows the school in its original setting with allotment gardens in front of the building which stretched all the way to Grange Road, that is, only a few feet from where the present Cleveland Centre stands. By 1908 all these gardens were covered by residential houses in Bedford and Baker Streets, which have themselves almost all been taken over for commercial and professional use. Today only the school's clock tower and the section on the right are still standing, and form part of the university.

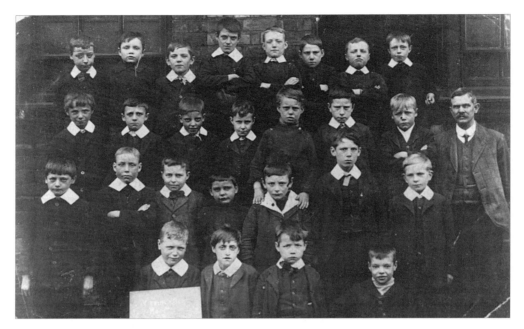

The boys of Standard IV of Victoria Road School, with their starched white Eton collars, are well groomed for their class photograph, which they are clearly taking very seriously as there is not a smile to be seen among them.

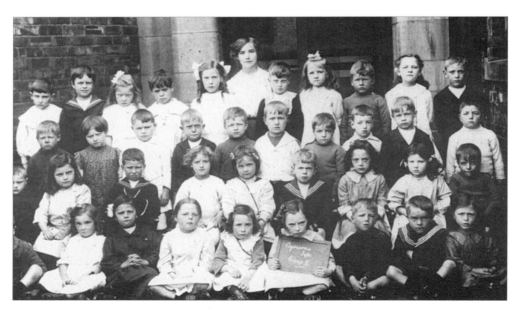

This picture of Ayresome juniors is typical of the period, *c.* 1907, when all the small pupils would be urged to attend for the school photograph in their best clothes, with faces scrubbed clean. Although the group is not as formal as the boys of Victoria Road School, there is still a lack of smiles.

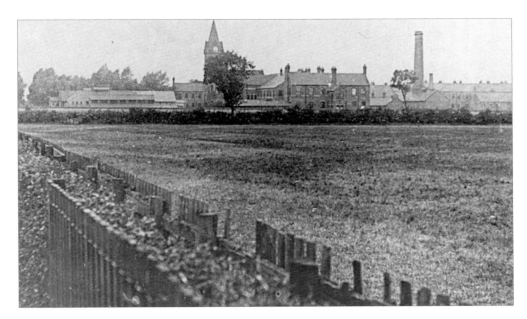

Holgate Tower, now demolished, and the familiar chimney which still serves Middlesbrough General Hospital are shown in their original rural setting, as observed from what is now St Barnabas Road.

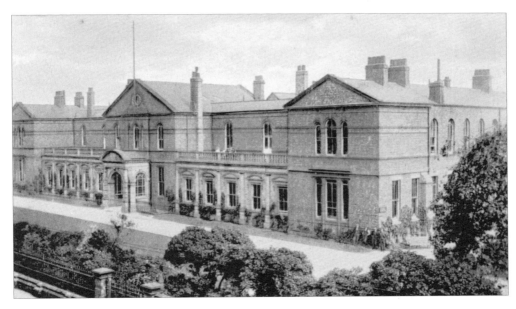

North Riding Infirmary, opened in 1864, still looks much the same as it does in this postcard view, although the trees and bushes have been sacrificed for road widening. Originally a general hospital, serving both the town and the nearby works in the Ironmasters District, the infirmary now specialises in ear, nose and throat ailments, although it is earmarked for closure when these services are transferred to the South Cleveland Hospital site.

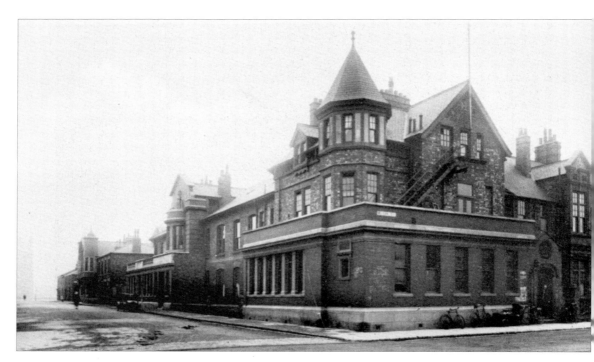

North Ormesby Hospital (above and below) had its origins in Dundas Mews off Corporation Road, transferring to a purpose-built hospital on this site in North Ormesby in May 1861. The hospital closed in 1981; all the buildings visible in these photographs were eventually demolished and the area redeveloped.

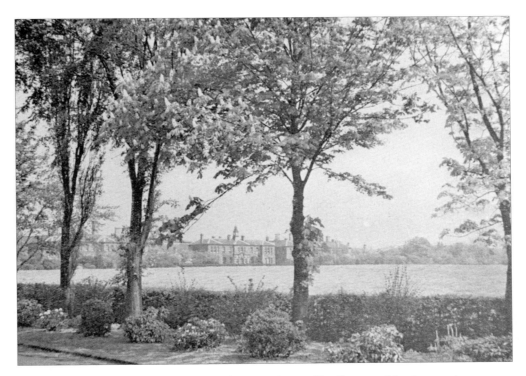

Set well back from Marton Road, St Luke's Hospital was officially opened by the town's mayor on 15 June 1898. Several additions over the years have come and gone, but the main building remains much the same. However, the grounds now form part of the ever-expanding South Cleveland Hospital complex. The view below is of the hospital chapel, which still stands to the left of the main driveway.

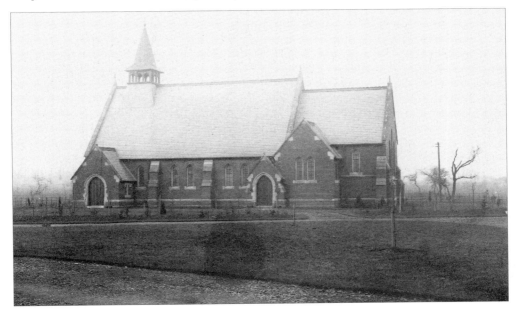

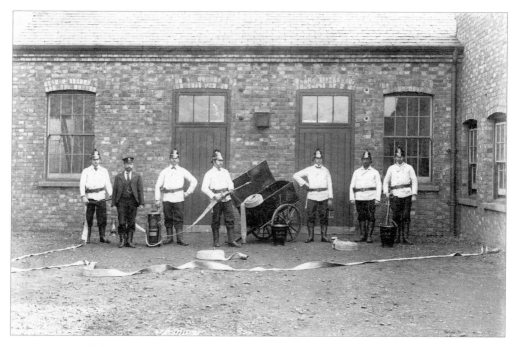

Originally, St Luke's was self-sufficient and as well as its own fire-fighters and the shoe-makers shown here, it had all the more usual complementary services, such as laundry, kitchens and bakery.

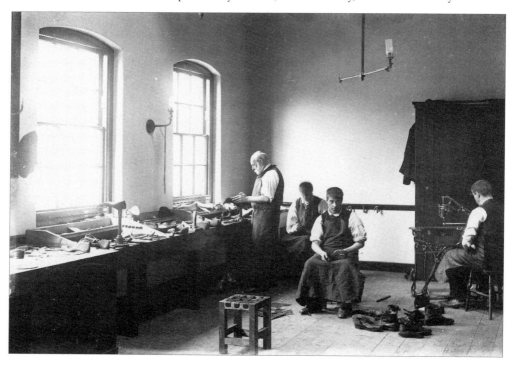

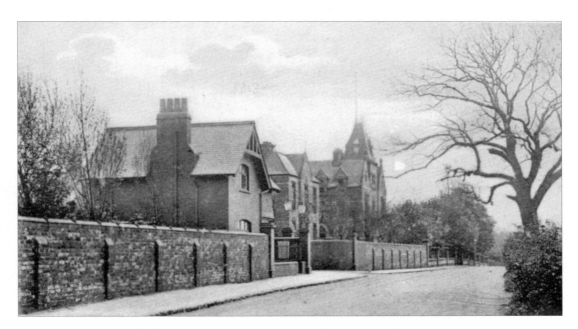

The once suburban look has gone from here, as today traffic roars past West Lane Hospital on its way to Acklam and the southern suburbs. Once known as the fever hospital, it opened in 1872, specialising in the treatment of scarlet fever, typhoid and smallpox. The picture below is of the tuberculosis ward, dating from 1912. Other isolation hospitals included a one-time floating hospital at Eston jetty and Hemlington Hospital, which officially opened in 1905 and was closed in 1989.

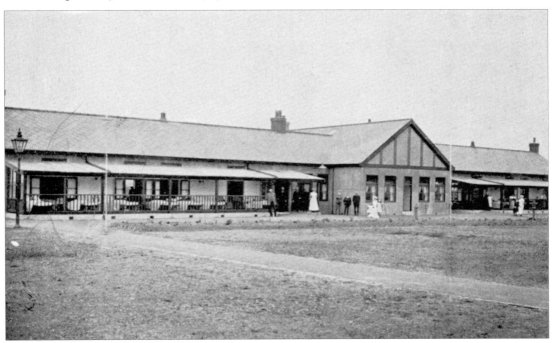

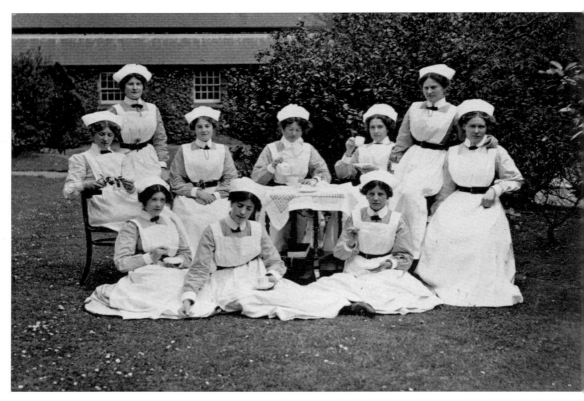

These nurses in their spotless white uniforms are from West Lane Hospital, and are enjoying a cup of tea in the grounds. This photograph was taken in 1912 when the area around the hospital was still relatively undeveloped.

SECTION TEN

SPORT & LEISURE

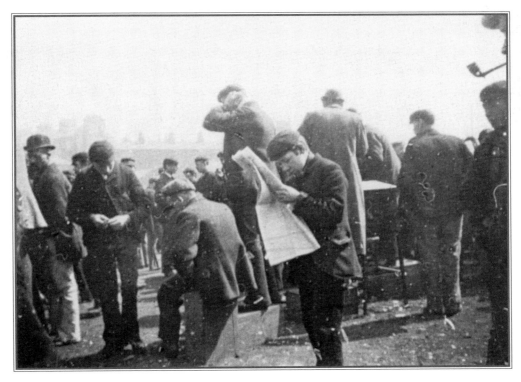

Not actually at the racecourse, but still having a flutter 'off course', these keen gamblers are betting 'unofficially', no doubt keeping their fingers crossed for a win and their eyes open for 'the law'.

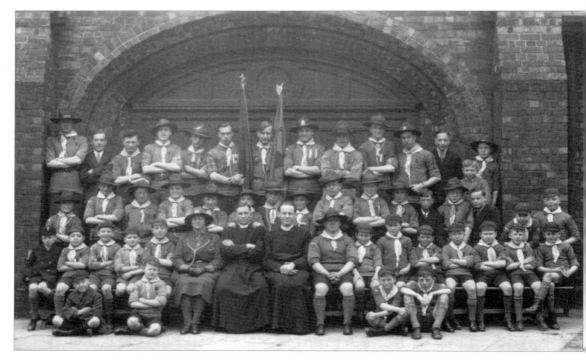

Scouting was a popular pastime for many Middlesbrough youngsters, and group photographs such as these were memorable events. The group above is pictured outside St John's Church Hall, while the West End 5th Middlesbrough troop pose in front of the Albert Park bandstand.

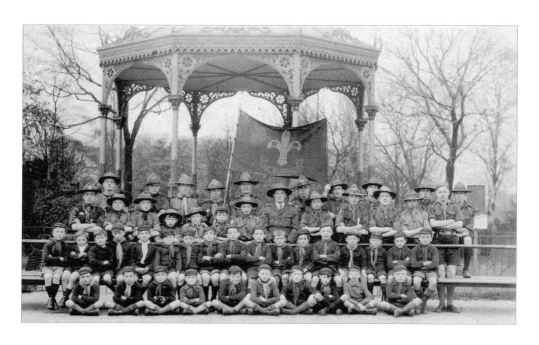

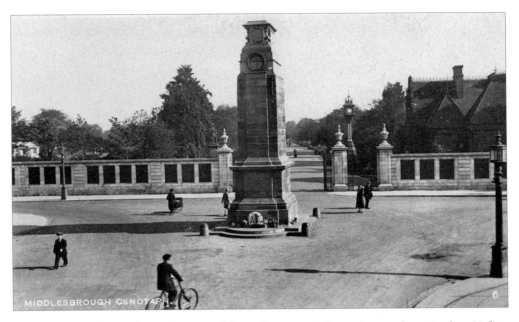

Little has changed since this 1930s view of the park gates and Cenotaph was taken. Standing 34 ft in height, the Cenotaph was unveiled on 11 November 1922. Behind can be seen the specially constructed walls of Portland stone with bronze panels bearing the names of 3,300 Middlesbrough servicemen who lost their lives in the First World War.

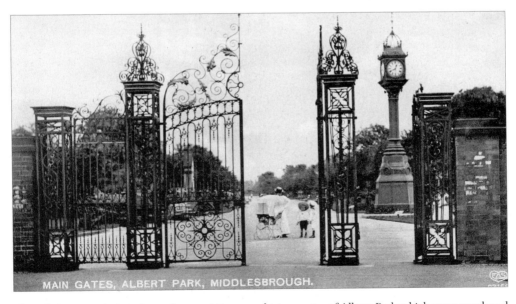

This 1913 postcard view shows the exquisite wrought-iron gates of Albert Park which were purchased by Henry Bolckow at an exhibition in York in 1867. They formed a fitting entrance to the park, named after Queen Victoria's consort, which was opened by Prince Arthur in 1868.

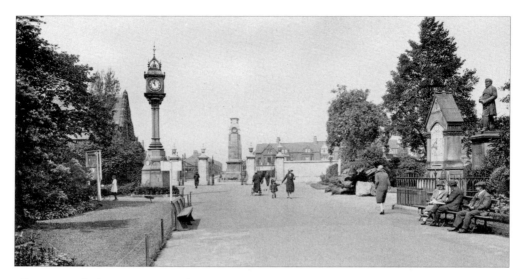

Taken just inside the main entrance, this view includes three of the park's best-known features – the ornate clock of 1900, the sundial of 1879 (the three dials of which give the time in Middlesbrough, Melbourne and New York) and the statue of Henry Bolckow, dating from 1881. The statue was originally located in Exchange Square, to which it has recently been returned, after spending sixty-one years in the park.

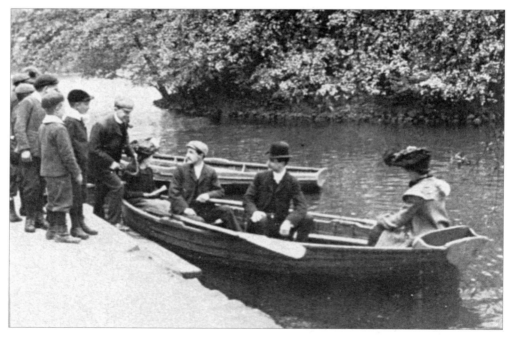

Albert Park has been a welcome 'green lung' for the townsfolk since its opening last century. However, in times gone by, it was a much more important venue for recreation than today and one of the most popular pastimes was a boat ride, without which no visit would be complete.

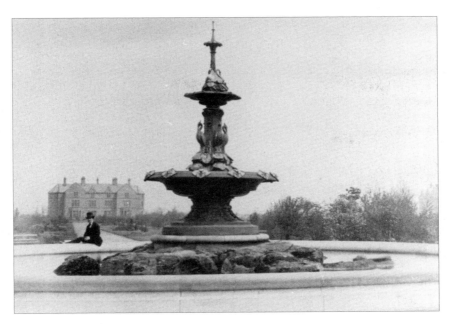

The park's original ornate fountain seems to stand tall among the newly planted trees and shrubs in this 1868 photograph. Park Villas in the background (then on the edge of town) are today part of one of Teesside University's halls of residence, after having been a section of Parkside Maternity Hospital since 1920. Below is a rare photograph of the avenue of flagpoles erected for the official opening of the park in 1868. Beyond the park, on a small rise at Grove Hill, Rhine Lodge, the home of H.J.H.B. Winterschladen, a local wine and spirit dealer, can be seen. Then 'in the country', the house still stands today, but intervening development makes this view impossible.

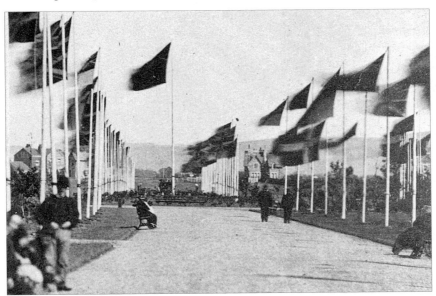

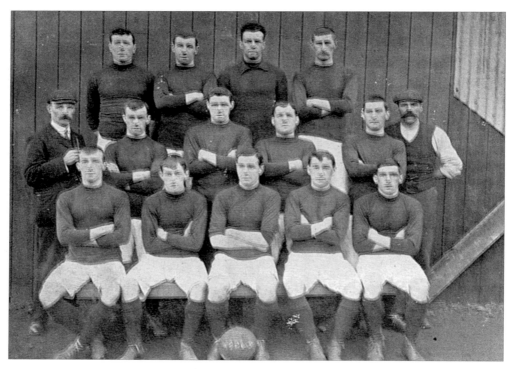

Britain's national game was well represented throughout the town with teams from schools, churches and social clubs. Above is the Middlesbrough Football Club team of 1904/5, then in its second season at Ayresome Park, and below is the Middlesbrough High School old boys' team of 1916.

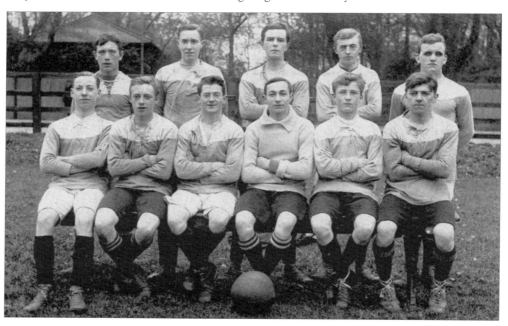

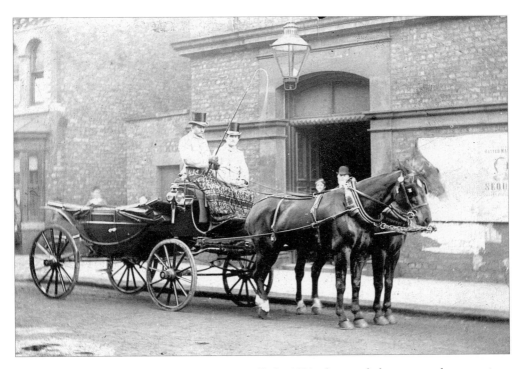

Taken in Park Street, at the rear of the Temperance Hall, this 1890s photograph shows a very elegant carriage, presumably waiting for someone of importance. A prominent poster on the wall behind is for Sequah, a well-known quack doctor of the time, who posed as a Red Indian and performed his act in the closing years of the century. The Temperance Hall was opened in 1877 and, seating 2,000, provided a venue for all types of events. Before its demolition to make way for the town's bus station, it was converted to a cinema, best remembered as the Marlborough, even though it was renamed the Metro in 1959.

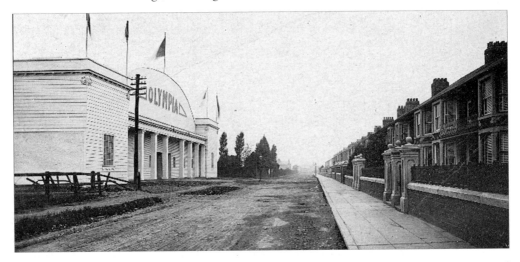

The Olympia skating rink in Oxford Road. Opened in 1909, it proved to be a short-lived venture and the site was sold for a garage in 1922.

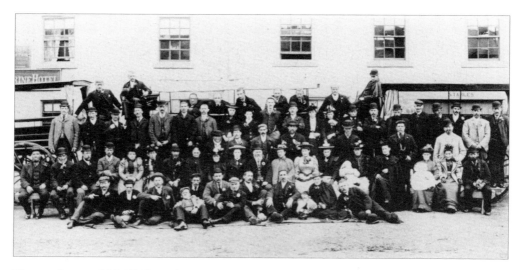

The employees of Middlesbrough Corporation Gas Works are seen gathered above for the annual outing. Affording the workers an opportunity for a welcome break from town, these outings were often organised jointly by the management and employees themselves.

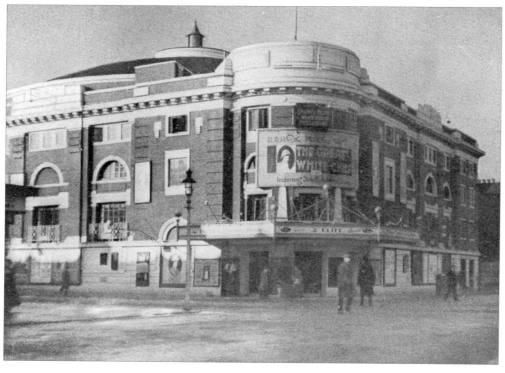

For almost sixty years between 9 July 1923 and 26 February 1983, the Elite (later the ABC) was one of the town's favourite cinemas. The building is now the Crown bingo club.

SECTION ELEVEN

IMPORTANT OCCASIONS
& SPECIAL EVENTS

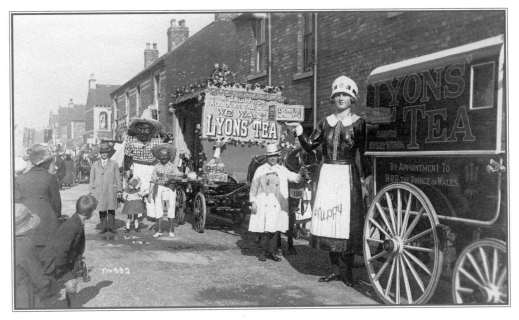

Sightseers, participants and floats gather in Emily Street ready to set off on a grand procession to mark the fund-raising charity carnival in September 1925.

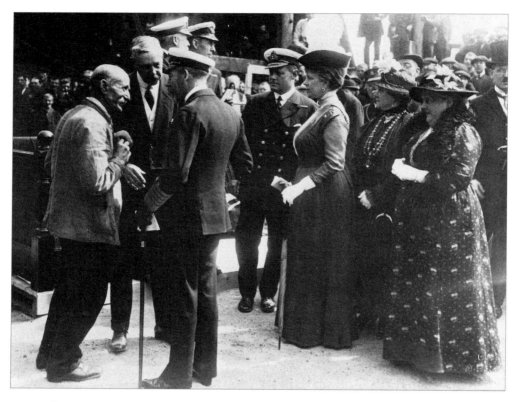

During the First World War their majesties King George V and Queen Mary made a surprise visit to the North-east, stopping at Teesside on 14 January 1917. Their visits to munition works, shipyards and docks included the shipyard of William Harkiss and Sons Ltd, where (above) some of the older workers were presented to them. Below, their majesties admire a model of one of the latest vessels.

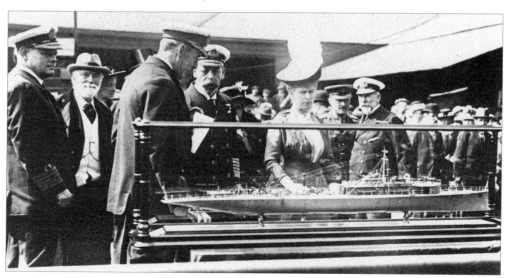

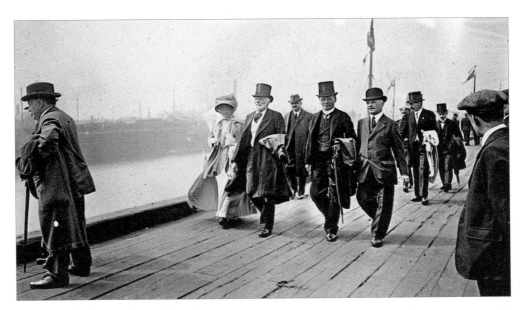

Seen here on 17 October 1911, the opening day of the Transporter Bridge, Prince Arthur of Connaught and the official party, including Sir Hugh and Lady Bell, the mayor and mayoress, tread the boards of the jetty at Dock Point.

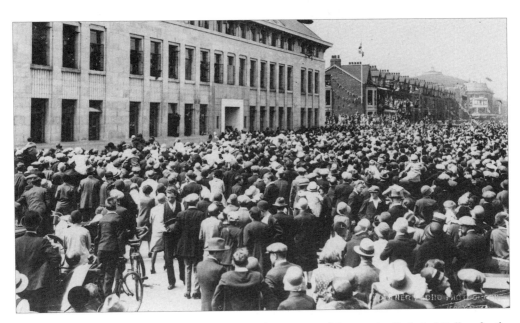

A large crowd gathers in Borough Road to witness the opening of Constantine Technical College by the Prince of Wales (later King Edward VIII) on 2 July 1930. Several local businessmen, especially shipping magnate Joseph Constantine, its chief promoter, contributed funds towards the cost of the building which still bears his name, although now part of the University of Teesside.

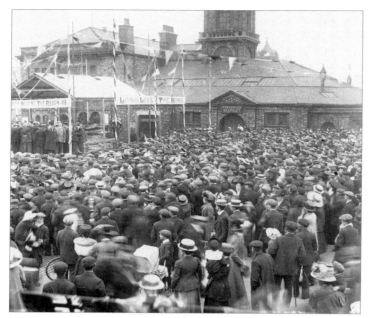

The highlight of the Middlesbrough celebrations to commemorate the coronation of King George V, on 22 June 1911, was an ox-roasting in the Old Town's Market Square. A vast crowd gathered to join the feast, at which, for the price of 1*s*., a commemorative plate could be purchased, together with a slice of the ox.

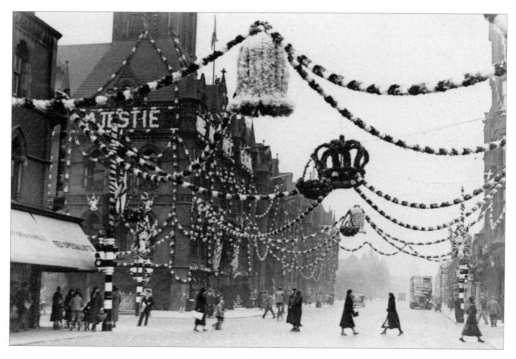

Albert Road and Corporation Road junction with the Town Hall are seen here with the decorations which were put up to celebrate the coronation of George VI and Queen Elizabeth (now the Queen Mother) in May 1937.

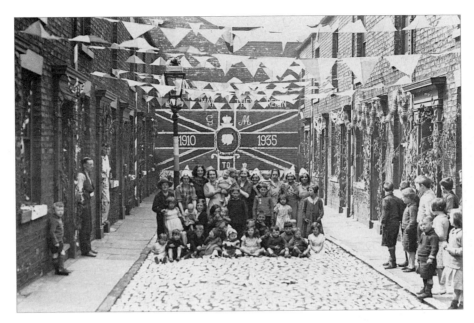

These images are typical of the street decorations put up in Middlesbrough to celebrate the Silver Jubilee of George V in 1935 and the coronation of George VI and Queen Elizabeth two years later. Below is Gloucester Street where it is party time for young and old alike and the youngsters are enjoying a festive tea. As we look down Gloucester and Peacock Streets towards Corporation Road, the slender spire of the Unitarian Church is just visible. The Civic Centre and Middlesbrough House cover part of this area today.

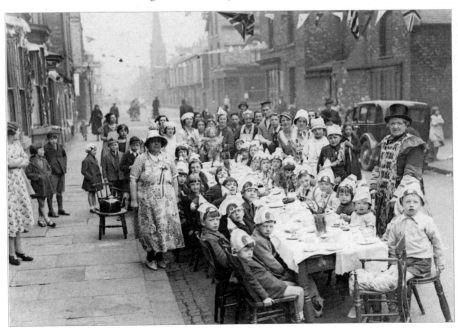

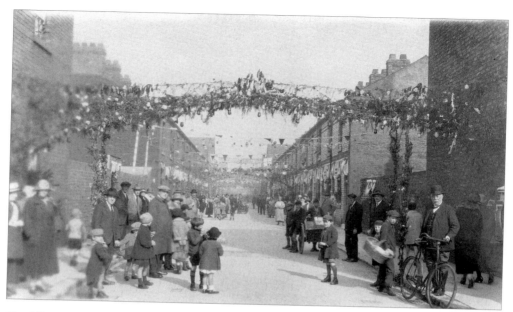

Hazel Street put out the decorations on the occasion of the 1925 Charity Carnival Week, when over £10,000 (a vast sum in those days) was raised, mainly for the North Riding Infirmary and North Ormesby Hospital.

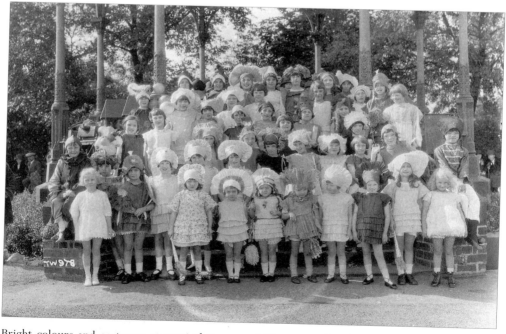

Bright colours and costumes at carnival time, as children pose for the camera at the Albert Park bandstand.

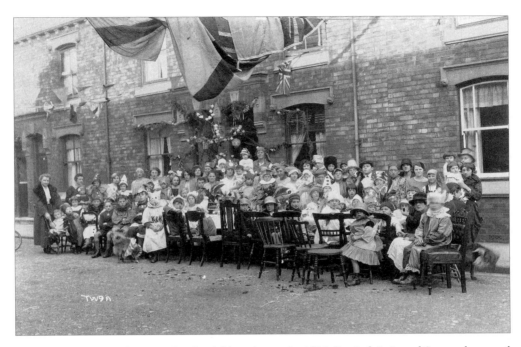

More organised street festivities for the children during the 1925 Carnival. In Laurel Street, above, and Waverley Street, below, food and fancy dress were the order of the day. Both of these streets are still surviving and, happily, will celebrate the millennium.

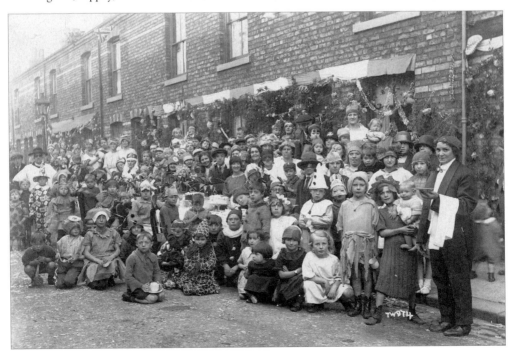

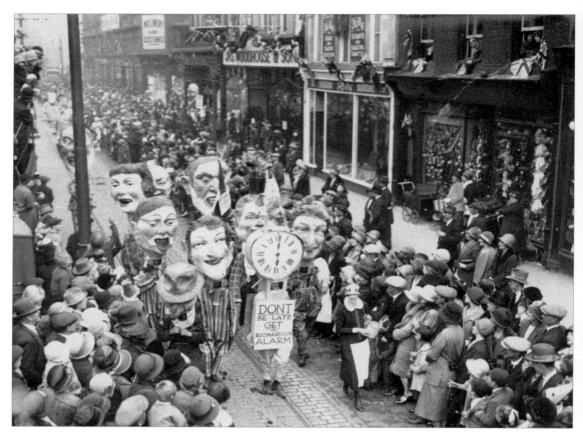

As with street decorations and parties, parades and marching bands were a common feature of national and local celebrations. Here part of the September 1925 Carnival procession is seen in Newport Road, between today's Binns and the bus station. Richardson's, local jewellers and watchmakers, are taking advantage of the occasion for some publicity.

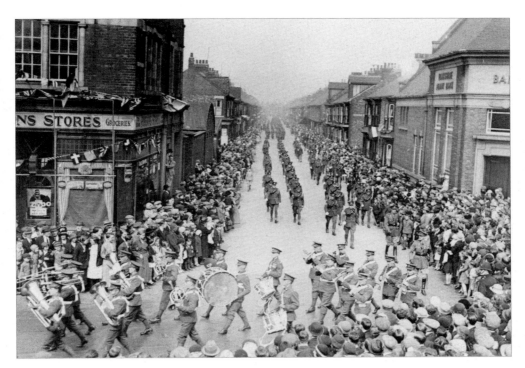

Many parades included military bands, as here, although the route along Gresham Road, above, would be much rarer than that pictured below, where the band is leaving Victoria Square, from where it would normally march along Linthorpe Road on its way to Albert Park.

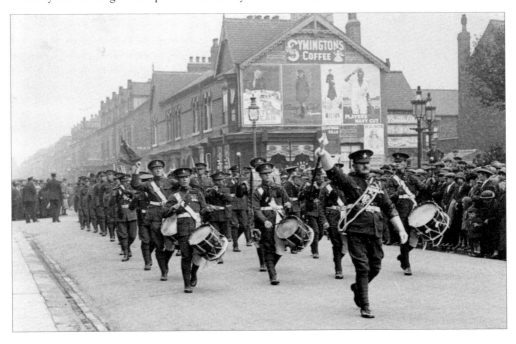

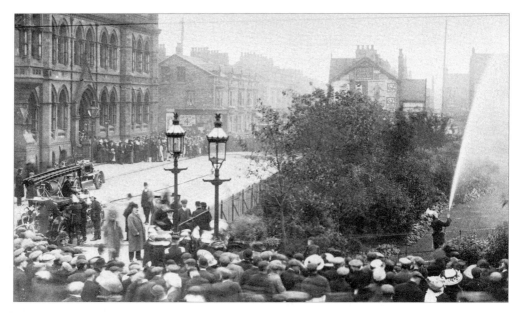

Curious crowds gather at Victoria Square on 4 October 1911 to witness the demonstration of Middlesbrough's first two motorised fire engines, which replaced the old horse-drawn vehicles. The two new engines were named 'Sir Samuel Sadler' and 'Lady Sadler', and carried the registration numbers DC 307 and DC 308.

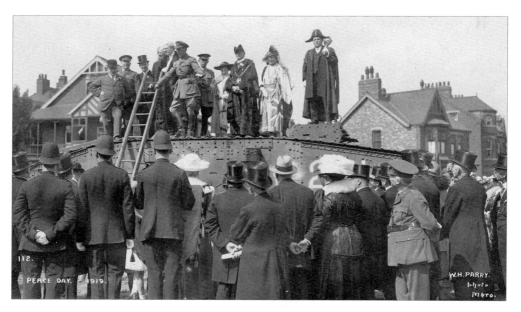

On a glorious summer day, the mood of the town's population matched that of the sunshine on Peace Day, 19 July 1919. A large procession on its way to Albert Park from the Town Hall paused here, at Park Road North, where tank no. 251 was officially accepted by the Corporation.

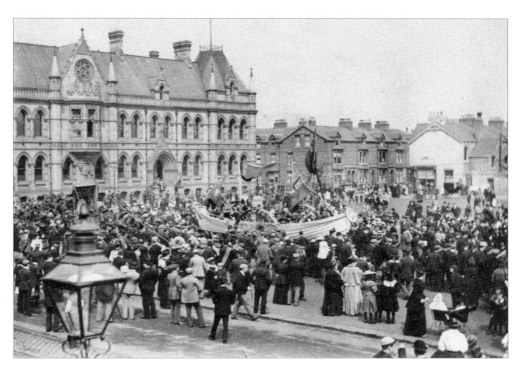

It's 'Lifeboat Saturday', an annual fund-raising event in the late nineteenth and early twentieth centuries. The above view was most probably taken on 22 June 1895, when a large crowd was attracted to Victoria Square (then nicknamed 'the Dark Continent'), from where a procession with marching bands toured the St Hilda's area, Cannon Street and the town centre, before ending up back in the square. On another occasion (below) the fund-raising lifeboat is seen outside Marton Road Schools.

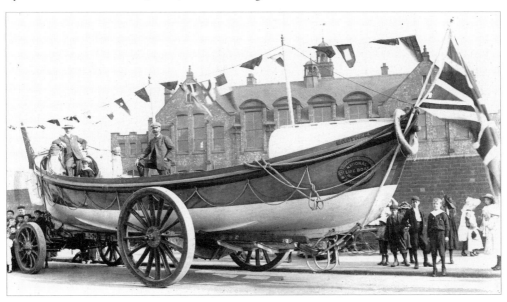

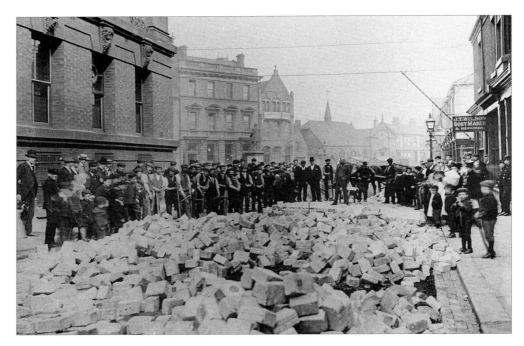

Quite a crowd has been attracted for the laying of a cobbled surface in Wilson Street, next to the Royal Exchange. Most of the once important commercial buildings in this photograph were demolished to make way for the A66 northern route flyover.

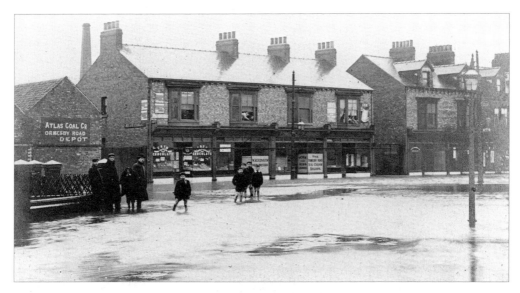

In 1903 parts of the town were flooded and this view shows the junction of Grange Road East and North Ormesby Road. Only the three-storey terrace on the right survives. North Ormesby Road itself now comes to an abrupt end, being blocked by the new A66 bypass.

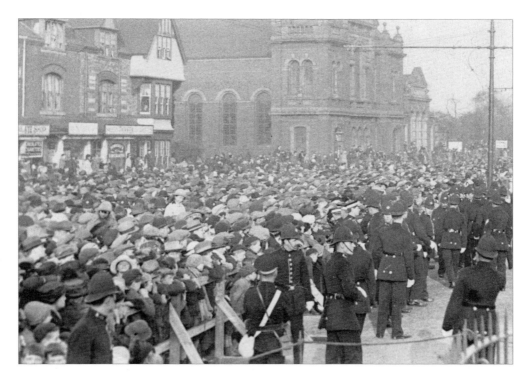

Massive crowds were always in evidence whenever there was a major event taking place in town. The crowds above were gathered for the unveiling of the Cenotaph on Armistice Day, 1922. Below, an equally large crowd has assembled for the opening of the Dorman Memorial Museum, even though it is a wet and dreary day.

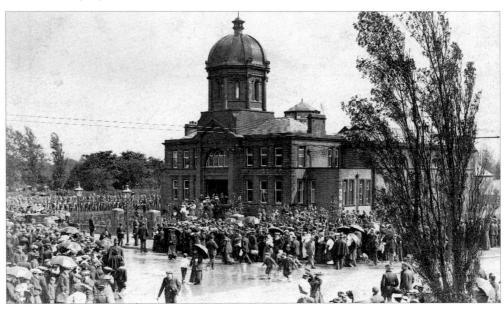

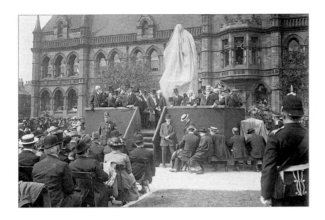

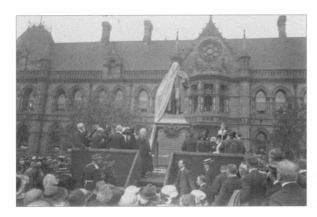

It is unusual to capture an unveiling as the cover is taken off. These photographs show the statue of Sir Samuel Sadler being revealed to the public for the first time in Victoria Square, on 21 June 1913.

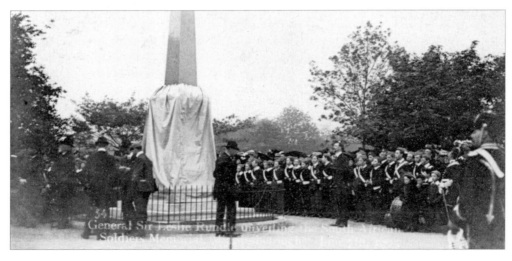

The obelisk to the fallen of the Boer War was officially unveiled on 7 June 1905. The ceremony seems to be in progress here but the memorial has yet to be unveiled.

SECTION TWELVE

THE FIRST SUBURBS

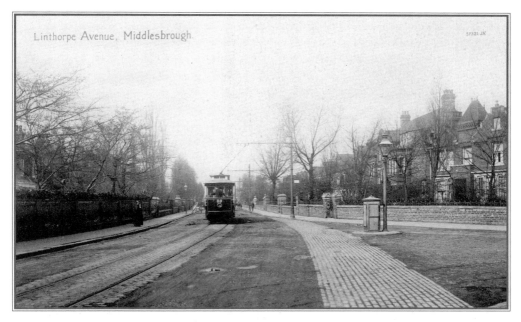

The Avenue, Linthorpe, looking towards Linthorpe village at the turn of the century. The Avenue still retains the impression of a prosperous Victorian suburb of large villas, surrounded by trees. Only present-day traffic disturbs the scene.

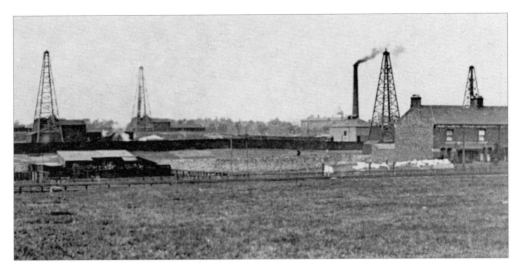

Not as affluent as Linthorpe, North Ormesby was still a very separate and distinct area, although much nearer to the industry and works. This rare view, taken from North Ormesby, shows the salt and brine wells located between Middlesbrough and North Ormesby, from which Saltwells Road takes its name. The row of houses on the right were known as Railway Terrace. The salt works have long gone and the fields seen in the picture are now covered by houses.

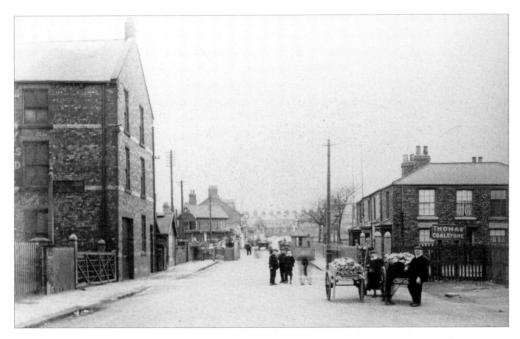

Looking towards Smeaton Street School and West Terrace, this fine view of North Ormesby crossing also shows the toll bar and signal box. To the left is a large building which was destined to be occupied by Greenwood's, a local pawnbrokers. Much of this area has also been swallowed by the new A66 road.

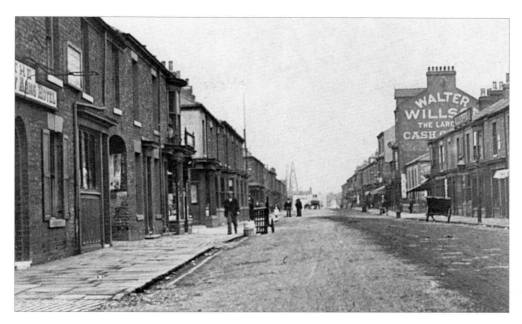

Now all gone, Smeaton Street is seen here looking towards the salt wells, just visible in the distance. The Worsley Arms, on the left, was one of six public houses which were once located in this busy thoroughfare. North Ormesby's principal shopping locality, Smeaton Street was bisected by the High Street which led directly into the Market Square.

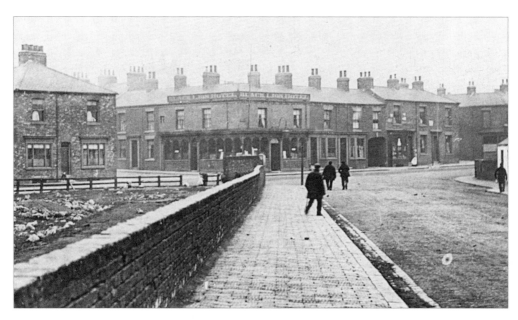

Also on Smeaton Street, the Black Lion at the corner of Pierson Street, seen here from Marsh Road, was typical of North Ormesby's 'watering holes'.

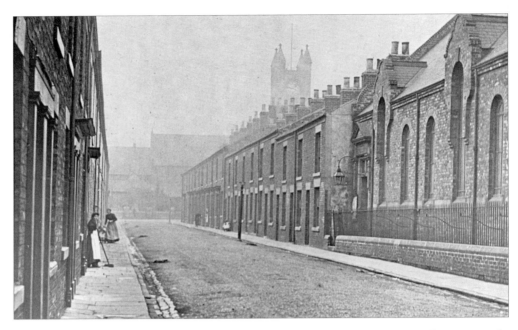

Peering above the rooftops of Nelson Street, North Ormesby, the clock tower of Holy Trinity marks time. To the right, the Salvation Army hall was in use from 1913 to 1974, having previously been a Methodist Chapel from 1882.

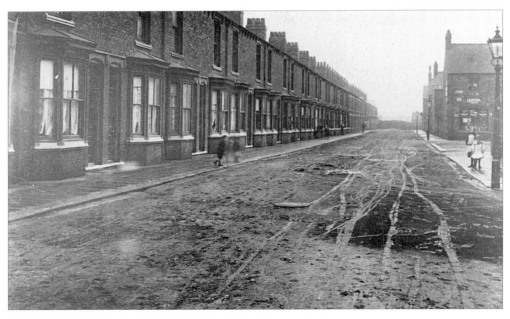

Cambridge Road, Cargo Fleet, looking from Roseberry Terrace towards Cargo Fleet Lane. Curiously, there were only houses fronting one side of the street. Nothing of the Cargo Fleet area remains today.

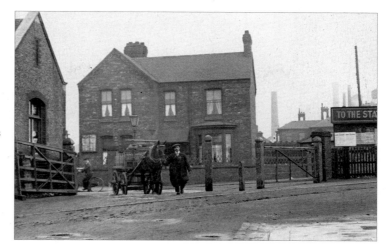

Surrounded by industry, the toll bar house guards the junction of Cargo Fleet Road and Marsh Road, North Ormesby. The old building still stands, now in close proximity to the new Riverside Stadium.

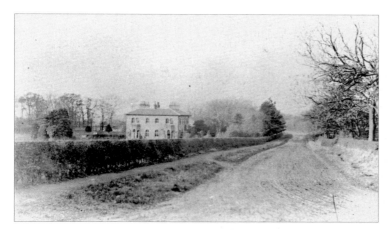

Built in 1860, this fine residence stood for over a century on Ormesby Road. Eventually, as the surrounding fields were built upon, the house itself was pulled down to make way for a garage and then, in 1994, for a supermarket. The name of the house, Park End, was given to the housing estate which was built around it in the 1950s.

The Red Lion, seen here in Ormesby village, was an old coaching inn, which has now been replaced by the Fountain Hotel. Once isolated from Middlesbrough, all the land between the two places has now been developed, so that Ormesby is a fully integrated suburb.

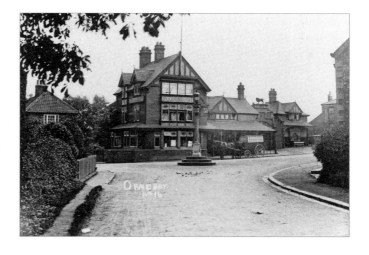

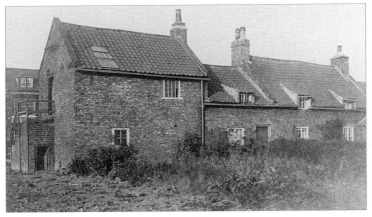

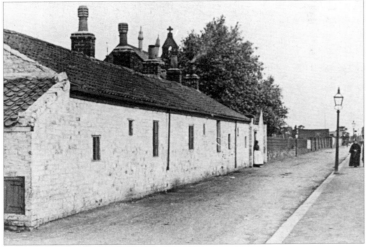

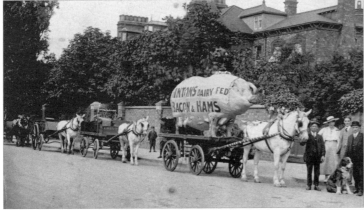

Linthorpe retained its village atmosphere and was physically separate from Middlesbrough until early this century. The top picture exemplifies the rural nature of the area, even as late as the 1890s, as Oldgate Farm was still standing on the corner of what were to become Kensington Road and Brompton Street. The middle picture shows the old 'white cottages' on the former cemetery road, which became St Barnabas Road. These cottages were not demolished until May 1935. Although Linthorpe was not fully 'urbanised' until well into the twentieth century, by Edwardian times the merchant and professional classes had started to settle in the area, building properties befitting their status. The large house seen in the bottom picture is now the Linthorpe Hotel, but it is not known what the occasion was that called for the parade of horse-drawn vehicles, led by the giant pig advertisement.

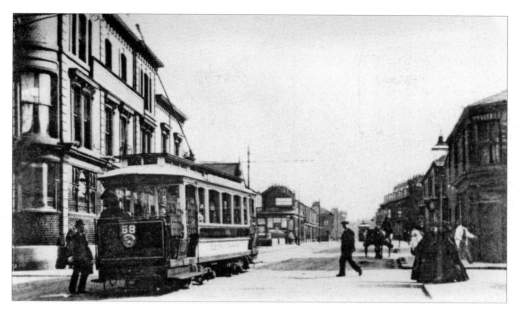

Electric tram no. 58 passes the Albert Park Hotel, built in 1868, as it heads towards Linthorpe village and Roman Road.

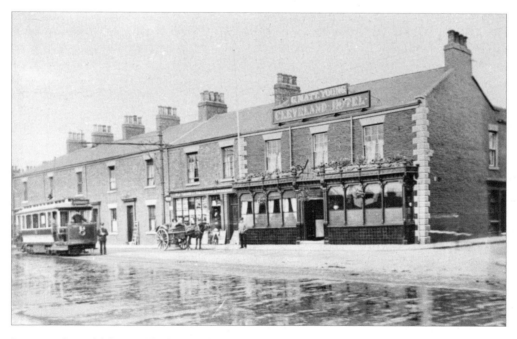

'New Linthorpe's' first public house, the Cleveland Hotel, whose original address was 50 Poplar Terrace, opened in 1855. This point marked the terminus of the old horse-drawn tram service. Like so much else, the area has changed considerably since this photograph was taken.

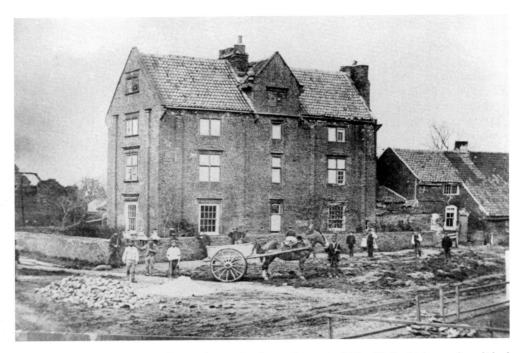

The above early photograph, taken in the 1860s, shows the original Blue Hall which was demolished in 1870 and replaced by the building shown below. Standing at the corner of Burlam Road and Roman Road, the second Blue Hall, like the first, was built on a grand scale. However, it too was demolished, in July 1927, and replaced by a housing development. Shipman's bakery traded from this corner from 1947 to 1996.

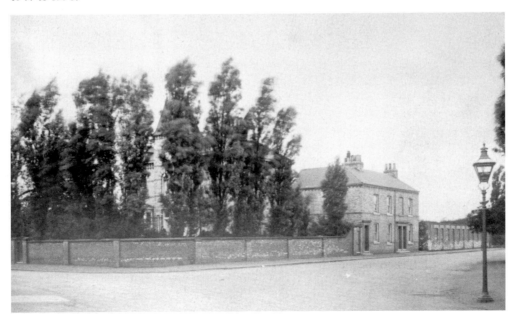

An unfamiliar view today, Marton Road, seen here in 1910, is no more than a rural lane. Possibly looking north towards Belle Vue, Marton Low Farm may be the building in the distance, on the left, with St Luke's Hospital staff cottages almost opposite.

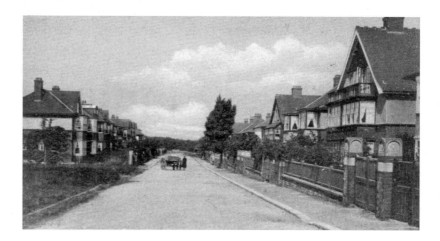

The centre photograph shows Marton Avenue and its suburban houses near Marton railway station which also served the nearby Marton Hall, the rear view of which is seen here. Once the home of H.W.F. Bolckow, Middlesbrough's first mayor and MP, all that remains today are the arches at bottom right which are adjacent to the Captain Cook Museum in Stewart Park.

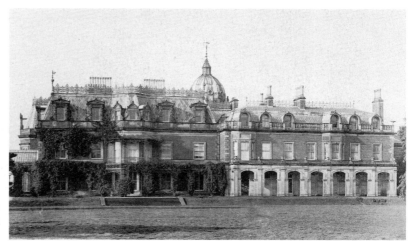

Today's suburban Acklam. The buildings of Lane End Farm (now covered by housing) once stood at the corner of Croft Avenue and Acklam Road. The present-day Green Lane is to the left, opposite the large tree. Below is Acklam Hall, a rare survivor from the seventeenth century. Now forming part of the Middlesbrough College campus, it was once home to generations of the Hustler family. St Mary's Church, visible on the left, stands on a site mentioned in the Domesday Book.

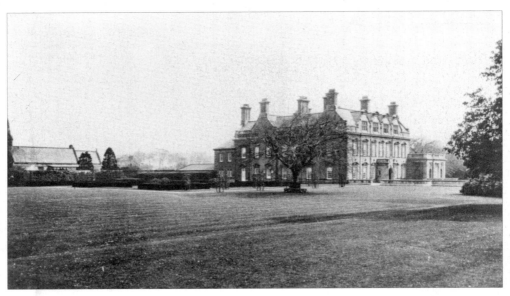

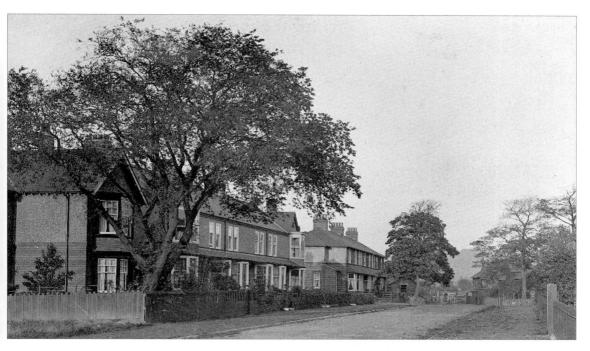

A summer day in leafy Nunthorpe. New Nunthorpe, built around the railway station, as seen in these views, is mainly a product of the twentieth century, while the old small village, some distance away, has a much older history.

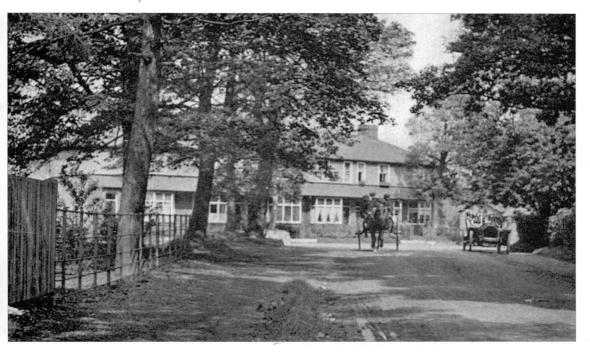

ACKNOWLEDGEMENTS

Iam very grateful to the many people who have helped and supported me over the years and hope that I offend no one by singling out those friends whose particular help and encouragement have enabled me to complete this book.

My special thanks go to Paul Stephenson to whom I am deeply indebted for all the dedication and time he has devoted to researching the facts behind the captions, for access to his private photographic collection and for his long-standing interest, help and involvement over the years. I would also like to thank him for the loan of photographs on pp. 12, 13, 69 and 90.

Heartfelt thanks must go to the following: to Cleveland and Teesside Local History Society and especially Jenny and Geoff Braddy for allowing me to take over the project from them and for their help in getting the book published; to all at the Photographic Department of the former Cleveland County Council, including Stewart West, Hazel Gall and particularly John Dale for all the assistance given to me in my research; to all the staff, over the last thirty years, of Middlesbrough Reference Library, Middlesbrough Archivist's Department and the Dorman Museum, with special thanks to Larry Bruce and Dave Tyrell; to David Smith for his help in transcribing my notes to a word processor, and for all his extra work in enabling the project to be finalised; to Mr and Mrs Ebdy for allowing me to use the Cannon Street photograph (p. 59); to Jeff Bowes for the photograph of Lords' Monumental Works (p. 38); to Dennis Wompra and Jessica (Jessie) Osborne who gave me considerable help in building up my collection; to Mr Ken Bell, manager of NatWest Bank, Cleveland Centre, for the photographs on p. 46; to my friends Cath and Mike Brown for much practical help and for giving me a place to stay in London during my early years of postcard collecting in the 1970s. I would also like to thank the ladies at Middlesbrough Information Centre.

I must also acknowledge the help of my friend Tariq Din and his daughter Nadia for keeping me informed on local developments during my many absences from town; and of my friend Moni Gill for his help, support and company, as well as all the driving around, especially over the last ten years; of friends abroad who have kept a lookout for old postcards, especially Doris and Keith Hankinson (in Perth, Australia), Alex and Rita Eastwood (in Auckland, New Zealand) and Elaine and Dennis Shepard (in Oregon, USA); of Tahiree Mahmood, who has spent countless hours with me over the past sixteen years searching out old postcards, and for giving up his valuable time at a moment's notice.

Last, but not least, particular thanks to my family who have put up with my postcard and photograph collecting for thirty years and especially to my brother Bari, who gave me my first postcard in 1966, to my sister Shahada, my nephew Khurram and my parents, all of whom have given me much encouragement and shown great patience; to my cousin Ejaz for his constant faith in my abilities over the last fifteen years and for all the time spent postcard hunting in and around London and the Home Counties, and to my nieces Ayshea and Faiza for making me endless cups of tea and snacks during my long sittings, and a very important thank you to my mother who is both the guardian and protector of my collection. Finally, a special thanks to my brother Hamed for allowing me to 'take refuge' at his home to complete this book.